Thomas Hirschhorn
Jumbo Spoons and Big Cake
The Art Institute of Chicago
Flugplatz Welt/ World Airport
The Renaissance Society at The University of Chicago
Co-organized by James Rondeau and Susanne Ghez
With essays by James Rondeau and Hamza Walker, interview by Okwui Enwezor

This book was published in conjunction with the exhibitions "World Airport" at The Renaissance Society at The University of Chicago (January 16–February 24, 2000) and "Jumbo Spoons and Big Cake" at The Art Institute of Chicago (January 23–April 9, 2000). Conceived as a single exhibition in two venues, the project that has occasioned this book was co-organized by James Rondeau for the *focus* series at the Art Institute and by Susanne Ghez for the Renaissance Society. This catalogue has been made possible by Susan and Lewis Manilow with additional support from the Elizabeth F. Cheney Foundation, The Getty Grant Program, and the Elizabeth Graham Firestone Foundation. Support for "*focus*: Thomas Hirschhorn" at the Art Institute was provided by Swissôtel Chicago; Howard and Donna Stone; Pro Helvetia, the Arts Council of Switzerland; and Mickey and Janice Cartin. Support for "World Airport" at the Renaissance Society was provided by the Swiss Benevolent Society of Chicago, Illinois; Etant Donnés; Swissôtel Chicago; the Peter Norton Family Foundation; and Pro Helvetia, the Arts Council of Switzerland.
First edition. Published by The Art Institute of Chicago, 111 S. Michigan Avenue, Chicago, Illinois 60603–6110. For more information on our books, please visit our Web site at www.artic.edu/aic/books. Distributed worldwide by D.A.P./Distributed Art Publishers, 155 Sixth Avenue, 2nd Floor, New York, New York 10013–1057. Edited by Susan F. Rossen, Executive Director of Publications, and Charles Mutscheller, Editorial Assistant. Production by Sarah E. Guernsey, Associate Production Manager. Design collaboration by Thomas Hirschhorn and Ann Wassmann, Associate Director of Graphic Design and Communications. Separations by Professional Graphics, Inc., Rockford, Illinois. Printed by Lowitz + Sons, Chicago. ISBN: 0–86559–181–4.

Contents

$19.95

BN

9/8/03

Foreword

"Chicago leads the way," proclaimed one headline in the national press. The year was 1926 and the occasion the opening of the Helen Birch Bartlett Memorial Collection at The Art Institute of Chicago—the nation's first permanent installation of then vanguard, Post-Impressionist paintings. In the years that followed, the museum amassed a significant and comprehensive collection of twentieth-century art. Indeed, from its staging of the famed Armory Show in 1913 to the acquisition of over one hundred choice objects from the Lannan Foundation in 1997, the Art Institute has had a distinguished history of support for modern and contemporary art. As we look forward to the new century, it is a fitting extension of this tradition that the first exhibition to open at The Art Institute of Chicago in the year 2000 features the work of one of the most engaging contemporary artists working in Europe today.

This two-part presentation of new and recent work by Thomas Hirschhorn marks the Swiss-born artist's first one-person museum exhibition in the United States. The project evolved out of a remarkable collaboration between the Art Institute and The Renaissance Society at The University of Chicago, an institution that has long been an important venue for challenging, new art. At the Art Institute, the exhibition was initiated by James Rondeau, Associate Curator of Contemporary Art, and Okwui Enwezor, Adjunct Curator of Contemporary Art, in the museum's newly renamed Department of Modern and Contemporary Art, for the *focus* series of single-artist exhibitions. We are grateful to both James and Okwui—and Renaissance Society Director, Susanne Ghez—for their shared commitment to bringing the very best in international contemporary art to the museum and to the city.

In the earliest days of the project, James Rondeau and Susanne Ghez approached Chicago collectors and patrons Lewis and Susan Manilow and asked them to consider sponsoring a shared exhibition catalogue. Eager to support the collaboration between two institutions to which they have long been devoted, the Manilows readily agreed. The book that resulted, published by the Art Institute in collaboration with the Renaissance Society, is unique in the Art Institute's publishing program in that it was designed and conceived by the artist (who was trained as a graphic designer) in collaboration with Ann Wassmann, the Art Institute's Associate Director of Graphic Design and Communications. I am grateful to the catalogue's contributing authors: James Rondeau, Okwui Enwezor, and Hamza Walker, Director of Education at the Renaissance Society. The catalogue was realized by a team from the Art Institute's Publications Department that included Susan F. Rossen, the Art Institute's Executive Director of Publications; Sarah E. Guernsey, Associate Production Manager; and Charles Mutscheller, Editorial Assistant.

Support for *focus: Thomas Hirschhorn*, at the Art Institute, was provided by Swissôtel Chicago, Howard and Donna Stone, Pro Helvetia, the Arts Council of Switzerland, and Mickey and Janice Cartin. We are very grateful for this assistance. It is our collective hope that Thomas Hirschhorn's extraordinary vision has been translated faithfully, intelligently, and usefully to the public.

James N. Wood, *Director and President*
The Art Institute of Chicago

779
H671

Foreword

If centuries are determined by events rather than number of years, the twentieth century has been relatively brief. Beginning with the shadow cast over Enlightenment ideals by World War I and ending with the break-up of the Soviet Union in 1989, this was an era marked by doubt as to the direction and/or possibility of moral progress. Although it has been a decade since former President George Bush declared the coming of a "new world order," we need to ask whether globalization, as currently manifest in commerce, and localization, as presently revealed in conflict, are proof that we must decide whether to shed or retain the doubts and longings of the century from which we have just emerged. In Thomas Hirschhorn's *Flugplatz Welt/World Airport*, a work that The Renaissance Society at The University of Chicago has just exhibited with great pride, and *Jumbo Spoons and Big Cake*, shown concurrently at The Art Institute of Chicago, the artist invited viewers to consider this question, a question for which there are no simple answers.

In June 1999, after viewing *World Airport* at the 48th Venice Biennale, I approached my colleague James Rondeau, Associate Curator of Contemporary Art at the Art Institute, with the idea of a possible collaboration. *Jumbo Spoons and Big Cake* was already in the works as part of the Art Institute's *focus* series. Without missing a beat, and in a spirit of true collegiality and generosity, he accepted my proposition. I remain indebted to him and to the Art Institute's Director and President, James N. Wood, for their openness and willingness to participate in this very special project.

The Renaissance Society and The Art Institute of Chicago have often been collaborators in forging Chicago's rich cultural heritage. Despite the differences in our missions, we share a common history, as numerous patrons have chosen to contribute to Chicago's cultural life by supporting both institutions. Hirschhorn's concurrent exhibitions made clear that this remains the case. On behalf of the Society, I would like to extend my sincerest gratitude to Lewis and Susan Manilow and to Howard and Donna Stone for their support of the publication and exhibition at both venues. They are exemplary patrons in their enthusiasm and good will.

As with any undertaking of this magnitude, there are numerous individuals and institutions without whom the exhibition at the Society would not have been possible. The Society is particularly indebted to the Swiss Benevolent Society of Chicago, for their crucial support of the project. Generous assistance was also received from Etant Donnés, the French-American Endowment for Contemporary Art; the Peter Norton Family Foundation; Pro Helvetia, the Arts Council of Switzerland; Swissôtel Chicago; and the Consulate General of Switzerland. Support for this catalogue was provided by the Elizabeth F. Cheney Foundation, the Elizabeth Firestone Graham Foundation, and the Getty Grant Program. Additional help for the exhibition was received from the CityArts Program of the Chicago Department of Public Affairs, a municipal agency; the Illinois Arts Council, a state agency; LLWW Foundation; the John D. and Catherine T. MacArthur Foundation; the Pritzker Foundation; the Sara Lee Foundation; the Siragusa Foundation; the WPWR-TV Channel 50 Foundation, and our membership.

At the Renaissance Society, I would like to thank Hamza Walker, Director of Education; Lori Bartman, Director of Development; Patricia Scott, Office Manager and Bookkeeper; Karen Reimer, Preparator and Registrar; Tanya Gregg, Kara Maniaci, Lisa Park, and Jacob

Schrekengost, Work/Study Assistants. Jean Fulton provided careful editorial help, and Tom van Eynde photographed *World Airport* as installed at the Society. I would especially like to thank Eden Morfaux, Thomas Hirschhorn's assistant, for his diligent work on this project.

Finally, our thanks to the artist, whose work is ultimately a challenge to our imaginations—not the imagination as it relates to romantic notions of creativity, but as it proves indispensable in conceiving and describing the future. Hirschhorn's work is fearlessly and fiercely rooted in the present for the sake of asking us whether we are capable of imagining a world that has yet to be. If his art serves as a memorial for the twentieth century, then it is best characterized as liberating the spirit and idealism of that century's utopian visionaries from the grasp of history.

Susanne Ghez, *Director*
The Renaissance Society at The University of Chicago

Acknowledgments

At The Art Institute of Chicago, special thanks go to James N. Wood, Director and President; Dorothy Schroeder, Associate Director for Exhibitions and Budgets; and Jeremy Strick, former Frances and Thomas Dittmer Curator of Twentieth Century Painting and Sculpture, for their support of the project. In the newly named Department of Modern and Contemporary Art, I am grateful to Okwui Enwezor, Adjunct Curator of Contemporary Art; Stephanie Skestos, Curatorial Assistant; Nicholas A. Barron, Departmental Specialist, and John F. Tweedie, Department Technician, and the team of art-installation professionals they supervised. Also to be thanked are William J. Heye, Manager of Building Trades, Physical Plant, and his crew of carpenters, electricians, lighting technicians, and painters; William T. Foster, Technician, and Jeffrey K. Pannall, Assistant Manager, Audio-Visual Programs; Darrell W. Green, Associate Registrar of Loans and Exhibitions, Museum Registration; Meredith M. Hayes, Director, and Lisa Key, Associate Director, Foundation and Corporate Relations Office of the Development Department.

The catalogue and exhibition would not have been possible without the help of a number of institutions, organizations, and individuals. In addition to those named by James N. Wood and Susanne Ghez in their forewords, I would like to mention Nora Gainer and Mary Jo Malone of Swissôtel, Chicago; Edward Jaun, Consul General of Switzerland, and Félix Naef, Deputy Counsel General of Switzerland, in Chicago; and Hanna Widrig, Cultural Counsel of Switzerland in Washington, D.C.

I would also like to acknowledge the assistance of Chantal Crousel, Galerie Chantal Crousel, Paris; Matthias Arndt, Arndt and Partner, Berlin; Susanna Kulli, St. Gallen, Switzerland; and Stephen Friedman Gallery, London.

Finally, my enormous gratitude to my co-curator Susanne Ghez, for her intelligence, generosity, and friendship; and, most importantly, to Thomas Hirschhorn, for his vision and dedication, his politics and his passion.

James Rondeau, *Associate Curator, Department of Modern and Contemporary Art*
The Art Institute of Chicago

Essay
Jumbo Spoons and Big Cake at The Art Institute of Chicago

James Rondeau
Associate Curator, Department of Modern and Contemporary Art,
The Art Institute of Chicago

I'm trying to connect things that I don't understand. I show it in my work in a stupid sort of way… When you work quickly, like me, you cannot control everything. I'm not here to show that I am able to control things well. This is what I call working politically. THOMAS HIRSCHHORN [1]

Over the last several years, Swiss-born artist Thomas Hirschhorn has produced a series of staggering works that are concerned, in the broadest possible sense, with issues of equity and inequity, power and powerlessness. His fabricated "displays" consist of commonplace, disposable, and yet charged products: scrappy cardboard, cheap plywood, recycled magazine pages, brown packing tape, clear cellophane wrap, and, importantly, gold- and silver-colored aluminum foil. With hundreds, often thousands, of these found elements as his raw materials, Hirschhorn engineers dense, obsessive, wildly energetic environments that incorporate individually sculpted objects and forms, awkwardly handwritten words and phrases, free-standing and wall-mounted collages on board, and, often, monitor-based video sequences and florescent lights.

Hirschhorn's pathetic, overburdened taxonomies of the everyday make manifest his own struggle to connect different aspects of his lived experience on a purely material level. Equal parts clichéd and poignant, his projects parody an obsessive attention to craft at the same time that they assert the potential for the handmade to transform the mass-produced. The process appears clumsy and careless, the results chaotic and excessive. The artist's work, however, is always governed by his own precise logic, wry sense of humor, and profound commitment to global social justice.

Trained as a graphic designer, Hirschhorn has consistently refused to accept the established vocabulary—both formal and linguistic—of traditional fine-art practices. Indeed, his ad hoc constructions seem to willfully mock conventional connoisseurship. They are in fact more appropriately considered as strategic occupations of given spaces (both public and private) than as conventional installations. A self-proclaimed artist-worker-soldier, Hirschhorn has positioned his project in terms that are more activist than aesthetic. "Becoming an artist," he has stated, "was a political choice. This does not mean that I make 'political art', or even 'political graphic art.' My choice was to refuse to make political art. I make art politically." [2]

8

I want to make a new work about the World State. The World State is about the need to eat, *or* the possibility of not eating. *The World State is inconvenient, confused . . . but everybody has to eat. That is the reason why there are jumbo spoons and the big cake.* (emphasis original)
THOMAS HIRSCHHORN

Jumbo Spoons and Big Cake (2000), like all of Hirschhorn's mature work, appears at first a confusing network of disparate, provisional elements. The silly, even childlike nature of the title betrays the artist's position of feigned stupidity. Indeed, Hirschhorn is an artist who likes to play dumb. It is, however, a decidedly critical affectation. He specifically conceived this keenly incisive work for The Art Institute of Chicago; it is presented here as a pointed complement to the exhibition at The Renaissance Society at The University of Chicago of *Flugplatz Welt / World Airport* (1999), an extravagant meditation on late twentieth-century global corporate capitalism.

At the Art Institute, Hirschhorn assembled a series of radically over-sized sculptural objects from cardboard and foil. Each of the twelve *Jumbo Spoons* serves as a monument or memorial to individuals and entities that the artist associates with failed utopian ideals. His selections range across a wide spectrum of social, cultural, and political history, from the specific to the generic, the distinguished to the ignoble. All of these references, however, conjure for the artist an ideological position (or series of positions) predicated upon the promise of a better world. For Hirschhorn none has been able truly to succeed. Figuring in the pantheon are the quintessential modernist architect Ludwig Mies van der Rohe (1886 – 1969), the Polish-born leftist revolutionary Rosa Luxemburg (1871 – 1919), the German philosopher Friedrich Nietzsche (1844 – 1900), and the Russian Constructivist artist Kazimir Malevich (1878 – 1935). Hirschhorn also included a city (the heavily touristed Venice, Italy), a nation (modern Communist China), and, surprisingly, the moon (presumably, a reference to futuristic fantasies of the moon as a post-national colony or twenty-first-century tourist destination). Ever-evolving historical inventions and concepts (the gun, fashion) coexist with actual events (the 1937 Nazi exhibition of "degenerate art" [*Entartete Kunst*]), and present-day corporate brand names (Swiss-made Rolex® watches, the Chicago Bulls basketball team).

Evenly spaced throughout the gallery, the *Jumbo Spoons*, each thirteen-feet tall, are oriented vertically against walls covered in flattened, blue-plastic recycling bags. The visual effect is interrupted occasionally by exposed patches of the gallery's original white surfaces, where the artist used black spray paint to make abstract, graffiti-inspired forms. Scraps of aluminum foil, spray-painted red, cover the bottom of each spoon, suggesting leftover food, or possibly even blood, spilling onto the floor. Regardless of the stains' origins, the inference is clear: the spoons have been used. An array of inexpensive, store-bought mirrors—designed to capture and multiply partial glimpses of gallery visitors and to reflect objects and images from opposite, facing walls—hang in clusters beside a series of collage boards documenting the subject of each homage. High on the walls around the perimeter of the gallery, Hirschhorn has installed nearly forty exposed florescent tubes that electrify the room with intensely bright, hot light. Taped to the floor in front of each spoon is a small, plastic-covered table proffering a selection of relevant reading materials (i.e., catalogues of works by Malevich, fashion magazines, Chicago Bulls paraphernalia, etc.). As a counterpoint to the intellectual and ideological positions represented by the spoons and their assorted documentation, Hirschhorn also taped to

the floor at the base of each table several different tools relating to manual labor (hammers, saws, wrenches, screwdrivers, etc.).

In the center of the gallery, *Big Cake* sits on a makeshift wooden table; eighteen feet in diameter, the cake is constructed of plywood, cardboard, and aluminum foil. The sculpture is divided into twelve, roughly equal wedges, each spray-painted a different color; if viewed from above, the piece might resemble a statistical pie chart or graph. The conically shaped top is decorated with a dense array of found photographic images, photocopies, texts, advertisements, graphics, and objects—including books (see pp. 16–18), real spoons and ladles, metal chains, jagged shards of broken mirrors, oversized artificial cherries, and mock frosting. Four television monitors imbedded within the cake's surface play a changing selection of video sequences that document generic activities related to war, eating, cooking, and labor. Around and under the cake, the artist placed dozens of cheap, multicolored, plastic buckets and basins, metaphorically ready to collect the leftovers that inevitably accompany the serving of cake: dripped frosting, crumbs, wasted slices, and so forth.

To be sure, the notion of excess is central to Hirschhorn's project. Challenging Mies van der Rohe's famous assertion, "less is more," the artist believes that more is always more, and less is always less. Hirschhorn's position implicitly recognizes that information is the most important—yet, at the same time, devalued—commodity in our super-saturated global media culture. Within his overwhelmingly dense environments, facts and figures, names and faces proliferate out of control. The artist has said: "I want to super-inform and super-detail, in order not to inform or detail. I do not want to communicate."[3] Unable to process the full range of possible meanings, the viewer is rendered confused, powerless, even mute.

Indeed, Hirschhorn positions the viewer as a single, unprivileged element within a significantly larger conversation, the dynamics of which are decidedly internal to the work of art itself. Every one of the disparate elements in the room is related and interdependent, connected by Hirschhorn's signature forms: rolled tinfoil extensions that resemble creeping vines, monstrous umbilical cords, or oversized tentacles. (In this work, for the first time, Hirschhorn supplemented the foil vines with silver metal chains.) These "conductors," as the artist calls them, create a closed-circuit network between the surfeit of objects, images, text, and video sequences. In formal terms, this emphatically low-tech wiring system (a primitive sculptural analogy to the Internet and other forms of advanced telecommunications) allows information, meaning, and, by implication, energy to flow within the space in an infinite number of directions simultaneously. As Hirschhorn has stated: "There is a will to make connections—to intellectually, physically, and politically link all of the elements of my project together. . . . [Often] the links are not there . . . it is up to me to make such connections visual. When I make links between objects with tinfoil—a portrait of Nietzsche, a portrait of Princess Diana, and a giant Rolex®—these links do not really exist, it is only a will. My work as an artist, as opposed to the work of a scientist or philosopher, is to make such links or connections."[4] Within Hirschhorn's emphatically democratic sign system, fashion logos, ads for luxury automobiles, and texts by philosophers and poets share equal conceptual weight with representations of homelessness, torture, genocide, famine, and war. These promiscuous, forced links ultimately suggest a viral metaphor, as if the process of intellectual connection might also be

one of physical contamination. Speaking of his larger critical practice, Hirschhorn has always asserted that he wants "to create something that is unclean, dirty. . . ."[5]

Every man was not born with a silver spoon in his mouth. ATTRIBUTED TO MIGUEL DE CERVANTES (1547–1616)[6]

For many, *Jumbo Spoons and Big Cake*, in both subject matter and scale, seems directly to reference the art of the Swedish-born, American Pop artist Claes Oldenburg, who is noted for his whimsical, often monumental, sculptures of commonplace objects, including cakes, spoons, forks, ice cream cones, fruit, and the like.[7] Hirschhorn, although nominally aware of Oldenburg's early achievements, completely rejects such a comparison, obvious as it may seem in formal terms. For him Oldenburg's comic, ironic, even intentionally absurd works function more as a celebration of an admittedly banal consumer culture than as a critique. As such they stand in direct opposition to Hirschhorn's aspirations for his own practice. And contrary to the contemporary, pop-cultural references that are central to Oldenburg's project, Hirschhorn invests in the historical and metaphoric associations implied by the spoon's form. In this context, the spoon's nearly universal recognition, utilitarian function, and humble origins (it is one of humankind's earliest inventions) imbue this utensil with rich symbolic potential.[8] After all the spoon is an implement whose presence can register the difference between hunger and nourishment, poverty and privilege. In fact Hirschhorn has repeatedly discussed his appropriation of the form in relation to Bertold Brecht's (1898–1956) famous dictum "First comes fodder, then comes morality!"[9] Brecht, the noted German poet and playwright, insisted that the dramatic and literary arts could be deployed as a social and ideological forum for leftist intellectual and political causes. A Marxist rallying cry for the equal distribution of resources, Brecht's statement encapsulates Hirschhorn's most fundamental political convictions.

Most directly, however, Hirschhorn has based his ironically exaggerated *Jumbo Spoons* on the idiom of miniature collectible spoons—the kind of souvenir often purchased to commemorate a trip to a city such as Venice, Paris, London, New York, or Chicago. Hirschhorn's presentation of *Jumbo Spoons* at The Art Institute of Chicago references the larger history of this peculiar and somewhat dated cultural practice, and recalls Chicago's singularly important position within the development of the collectible spoon in the United States.

The first genuine souvenir spoons celebrated the lives of Christ's twelve apostles. Documented in Europe as early as the sixteenth century, these tokens were customarily given by sponsors to children at Christian baptisms (a tradition not unrelated to the nineteenth- and twentieth-century American custom of birth and christening spoons). They became prized collectibles throughout the continent in the seventeenth and eighteenth centuries, particularly with the development of such specialty serving utensils as the teaspoon. The earliest colonists in North America collected spoons—as both valuable family heirlooms and informal mementos. The great vogue of the modern collectible spoon, however, had its beginnings in the United States in the 1880s.[10]

Chicago's 1893 Columbian Exposition, celebrating the four-hundredth anniversary of Christopher Columbus's "discovery" of the American continent, was both a definitive moment in the cultural life of the United States and the apogee of the souvenir spoon's international popularity. More souvenir spoons were made to commemorate this event

than any other in recorded history, before or since. Almost overnight the collecting of spoons (honoring people, places, historical events, famous buildings, religious figures, even insects and animals) became for many not merely a hobby, but a consuming rage.[11] For several subsequent decades, organized tours, day excursions, family vacations, even visits to relatives often occasioned the modest purchase of a souvenir spoon, either to be presented as a gift or kept for the personal collection of the traveler. Although the fad had subsided by the early 1920s, it remains today a staple, if somewhat antiquated, fixture of international tourism and continues to sustain an active niche market of hobbyists, collectors, trade publications, and Internet websites.

The only witchcraft exercised in Salem now is upon the pocketbook of the summer person who has a fad for souvenir spoons and a taste for the delectable confections made there. . . . Coins large and small fly from their hiding places when coming into proximity with these luxuries. HELEN ARCHIBALD CLARKE, 1909[12]

Installed at The Art Institute of Chicago, *Jumbo Spoons* intentionally mimics a museum gift shop, or other similar sites of cultural tourism. As souvenirs, much like brightly patterned umbrellas inspired by Impressionist paintings or coffee mugs with decorations based on compositions of Abstract Expressionist canvases, collectible spoons represent for Hirschhorn a misunderstanding of both art and culture.[13] This is particularly true of commemorative spoons, which are false objects in a number of ways. As collectibles, miniature spoons deny their basic utilitarian function: they are used neither for serving nor for eating. The commodity value of these ersatz treasures is also entirely dependent upon pretense and artifice. Often ornate—or "fancy" in the parlance of contemporary collectors—the spoons self-consciously imitate the possessions of the wealthy, in both material and design. (The "silver spoon" after all has long been colloquial shorthand for privilege.) Miniature collectible spoons are rarely made of precious metals, however. As mass-produced items, mostly bought and sold cheaply, such spoons assume a status that is entirely different from the valuable heirlooms they intend to simulate. Hirschhorn's use of commercial-grade aluminum foil—itself a poor substitute for sturdy metal—highlights the essentially economic nature of the form's transformation from the highbrow to the pedestrian.

As objects relating or belonging to specific locations or cultures, collectible spoons also fail, since their design is essentially generic. In this idiom, every place is represented in nearly the exact same terms. Displayed in the curio cabinet at home, a spoon engraved with a famous view of Venice looks like one of Paris, that with Paris nearly identical to one of Amsterdam, and that with Amsterdam the same as one of Rome, and so forth. Even the representations of these places become similar: simply substitute St. Mark's Cathedral for the Eiffel Tower for a windmill for St. Peter's Basilica, etc. Denying the variances of local contexts, these apocryphal trinkets effectively homogenize the (western) world. Cities not validated by the international tourist economy—Dakar, Johannesburg, Taipei, Monrovia, Amman, and so on—are, for the most part, rendered invisible in the traveler's pantheon. Taken as a whole, a souvenir-spoon collection, whether from the 1890s or 1990s, is not intended to accurately register any real understanding of the world, but rather aspires to document and reflect the owner's cultivated sense of sophistication. Essentially, these spoons reduce the experience of international travel to the level of the status symbol (a centuries-old equation that recently has acquired new meaning among increasingly

nomadic, putatively global contemporary art professionals). On a variety of levels, Hirschhorn makes clear that *Jumbo Spoons* is intended as a pastiche of a pre-existing pastiche. Importantly, however, his appropriation is entirely without sarcasm. Acquired with care and presented with pride, collectible spoons are, as the artist has acknowledged, "inauthentic, but with love."

Qu'ils mangent de la brioche. (Let them eat cake.) ATTRIBUTED TO MARIE ANTOINETTE, QUEEN OF FRANCE (1755–1793)[14]

At the beginning of the twenty-first century, our experience of the globe is determined, more than ever before, by the ease, speed, and affordability of international travel and by an ever-expanding network of technological links that allow for rapid communication between geographically distinct locations. The ramifications of this revolution are profoundly economic. Over the past two decades, trade between nations has soared to more than twenty percent of the export activity of the industrialized world, and to about twenty-five percent of total global financial activity.[15] This has led to unprecedented prosperity in the United States (and in a handful of other industrialized countries). Across the planet, localized identities, currencies, languages, and cultures are slowly being altered, if not replaced, by newly integrated global markets. Indeed, "globalization" was one of the most often-used, yet ill-defined, buzzwords of the 1990s. Essentially, the word describes a complex model of multinational exchange centered on the triumph of unrestrained, free-market capitalism.

One well-rehearsed argument positions globalization as a liberation theology, a great equalizing force that promises not only unimagined wealth but also the spread of democratic values; improved access to education, health care, and jobs; and a more equitable distribution of resources. The worldwide spread of American-styled capitalism, however, inescapably produces insidious forms of cultural domination. To be sure, capitalism's "survival of the fittest" logic has wide-ranging social implications beyond the marketplace. As demonstrated by the recent, explosive protests in Seattle during the late November 1999 conference of the World Trade Organization, there are real and impassioned counter arguments to the prevailing profit-driven optimism about globalism. Skeptics decry the process as a kind of economic steamroller, driven by an engine that eradicates regional difference and consolidates resources in the hands of a few. (The World Bank recently reported that the three richest men on the planet have a combined net worth that exceeds the total Gross Domestic Product of the forty-eight poorest countries.[16]) Given the circumstances, many developing nations cannot compete fairly in open, increasingly deregulated business environments. On a cultural level, American popular tastes continue to exert themselves according to a hegemonic, neo-colonialist model, evidenced by the worldwide reverence for brand names such as Starbucks®, Nike®, or Levi's®, and the singular authority of mainstream Hollywood film and television exports.

Big Cake must be understood as a critique of globalism—or more precisely a critique of the rhetoric surrounding its effects on world populations. Framed by the cheap props of an invented cultural economy, *Big Cake* might well have been prepared for a massive, multinational, corporate-sponsored celebration of the new millennium. Intended as a symbol of joy and a source of pleasure, an ordinary party cake is supposed to be divided into equal parts and distributed evenly among a group of polite and patient guests. Here, however, despite the twelve "equal" slices, something has gone horribly wrong. Lacking any of the

usual appeal of the requisite party staple, *Big Cake* has been trashed—one might even say victimized—by a gluttonous feeding frenzy. "The cake is all messy, like a cake after a dinner or after a party," Hirschhorn has stated.[17]

Within the artist's trenchant sculptural vocabulary, *Big Cake* reads as an intentionally dumb metaphor for a troubled world. "The cake," Hirschhorn has asserted, "is divided, stolen, conquered, cheated, spoiled, raped . . . a disaster . . . too many people wanted too much." Extending the possibilities of the willfully stupid metaphor, the artist humorously linked his feelings about globalism with the notion of post-party indigestion. Confronting viewers with an immense, desecrated, poisonous cake, Hirschhorn in fact aimed to provoke in the viewer an analogous sense of psychic discomfort. The subtly uneven slices can be read as a mocking reference to the ways in which natural and economic resources are intensely subdivided and unevenly distributed among nations. Throughout his mature career, Hirschhorn has consistently articulated the persistence of certain oppressive political exigencies: regional wars in Chechnya, East Timor, Kosovo, Rwanda, Bosnia, Sierra Leone, Angola, and the Falklands, among others; natural disasters, global warming, and environmental collapse; poverty and famine; the proliferation of weapons of mass destruction, terrorism, large-scale human-rights violations, the spread of epidemic viruses, and so on. In this work, the specter of global, sociopolitical trauma is more overt than ever before. In lieu of frosted flowers and candles, the top of *Big Cake* is littered with myriad references to social injustice, world crises, and disasters. Moreover, the whole sculpture is lit by a series of intensely bright spotlights, generating light and heat; for the artist, these are akin to small, "localized explosions."

Contextualized by the perverse Grand Tour of *Jumbo Spoons*, the *Big Cake* emerges, finally, as a concoction of excess, acquisitiveness, and violence. The product of our own collective anxiety, guilt, and fear, it is the underbelly of the new world order. Amazingly, however, Hirschhorn manages to assert the presence of these desperately frightening realities without indulging in overtly political, didactic, or dogmatic strategies. Instead, he succeeds brilliantly in disrupting the meta-language of globalism with his own brand of theatrical excess, ultimately transforming the discourse from tragedy to burlesque.

Notes

Unless otherwise noted, all quotes from Thomas Hirschhorn are from correspondence or conversation with the author, between Dec. 1998 and Dec. 1999.

1. Thomas Hirschhorn, cited in Pascaline Cuvelier, "Weak Affinities: The Art of Thomas Hirschhorn," *Artforum* 36 (May 1998), p. 134.

2. Hirschhorn, cited in Alison M. Gingeras, "Thomas Hirschhorn: Striving to Be Stupid," *Art Press* 239 (Oct. 1998), pp. 20–21.

3. Hirschhorn, in Venice, *"dAPERTutto" La Biennale di Venezia. 48a Esposizione internazionale d'arte*, exh. cat. (1999), p. 128.

4. Hirschhorn (note 2), p. 25.

5. Hirschhorn, cited in Jean Yves Jouannais, "Thomas Hirschhorn: Wagering on Weakness," *Art Press* 195 (Oct. 1994), p. 58.

6. See John Bartlett, *Familiar Quotations*, 15th ed. (Boston, 1980), p. 171.

7. See particularly works by Oldenburg such as *Floor Cake* (1962; New York, Museum of Modern Art), *Spoon Bridge*

with Cherry (1987; Minneapolis, Walker Art Center), *Leaning Fork with Meatball and Spaghetti I* (1994; Collection Phillip T. George, Florida).

8. The artist first used the spoon form in his outdoor work *Skulptur-Sortier-Station* (Paris, Centre Georges Pompidou, Musée national d'art moderne) for the 1997 "Sculpture Projects" exhibition in Münster, Germany. In one section of this large, outdoor cardboard construction, he installed a number of silver-foil objects in the shape of stalagmites and stalactites before a large sign that read "Spoons for Collectors," along with a series of collaged images of collectible spoons. In *World Airport*, a number of over-sized, aluminum-foil spoons are hidden underneath the large table, or runway.

9. "Erst kommt das Fressen, dann kommt die Moral." See Bertold Brecht, *Die Dreigroschenoper* (Berlin, 1928), Brecht's assertion is probably based on a statement by the English aesthetician John Ruskin in his *Fors Clavigera* (1876): "The first duty of government is to see that people have food, fuel, and clothes. The second, that they have means of moral and intellectual education"; see Bartlett (note 6), p. 573.

10. The first patented spoon design commemorating a place or person (in other words, the first souvenir spoon) is the *Niagara Falls Suspension Bridge Spoon*, patented in 1881 by Myron H. Kinsley; see Dorothy T. Rainwater and Donna H. Felger, *American Spoons: Souvenir and Historical* (Camden, N.J., 1968), p. 15.

11. Ibid., p. 225.

12. Helen Archibald Clarke, *Longfellow's Country* (1909), in Albert Stutzenberger, *American Historical Spoons: The American Story in Spoons* (Rutland, Vt., 1971), p. 35.

13. See Hirschhorn's comments in Gingeras (note 2), p. 25, regarding his work *VDP, Very Derivated Products* (1998). The artist designed this temporary work in part as a response to the street-front retail operation at the former entrance to the Solomon R. Guggenheim Museum, New York (Soho), when he participated in the exhibition "Premises: Invested Spaces in Visual Arts, Architecture, and Design from France, 1958–1998."

14. Commonly attributed to Marie Antoinette, the aphorism is actually much older. Jean Jacques Rousseau referred in his *Confessions* (1740) to a similar remark as a well-known saying. King Louis XVIII, in his *Relations d'un voyage à Bruxelles et à Coblentz en 1791* (1823), attributed such a phrase to Marie Thésèse (1638–1683), wife of Louis XIV: "Why don't they eat pastry?" ("Que ne mangent-ils de la croûte de pâte?"); see *The Oxford Dictionary of Quotations,* 3rd ed. (Oxford, 1979), pp. 328–29.

15. Michael J. Mandel and Paul Magnusson, "Global Growing Pains," *Business Week* 3659 (Dec. 13, 1999), p. 40.

16. Fareed Zakaria, "Across the Great Divide," *Facing the Future: Issues 2000*, special issue of *Newsweek* 134, 24A (Dec. 1999–Feb. 2000), p. 9.

17. When asked about identifying *Big Cake* as a cake rather than as a pie, Hirschhorn said he based his decision, in large part, on the various meanings in German of the word cake ("Kuchen"): not only can it mean "blood clot," but it also functions as a slang word for "shit."

Book List

List of publications included in *Jumbo Spoons and Big Cake*
at The Art Institute of Chicago

Black Beauty and Hair (Dec. 1999/Jan. 2000)./*Cosmopolitan* (U.K.) 124 (Dec. 1999)./*Elle* (U.K.) (Jan. 2000)./*Esquire* 9 (Nov. 1999)./*Glamour* (Dec. 1999)./*Marie Claire* (U.K.) 137 (Jan. 2000)./*Marie Claire* (U.S.) 7 (Jan. 2000)./*New Woman* (U.K.) 138 (Jan. 2000)./*Pro Basketball Edition* 6 (1999–2000)./*Spoon: Deluxe Odyssey* 5 (1999)./*L'Uomo Vogue* 304 (Oct. 1999)./*Vogue* (Japan) 12 (Dec. 1999)./*Vogue* (U.S.) (Dec. 1999)./*Vogue* (U.K.) 166 (Jan. 2000)./Adam, Peter. *Arts of the Third Reich*. London: 1992./Baudrillard, Jean. *The Consumer Society: Myths and Structures*. London: 1998./Becker, Jasper. *Hungry Ghosts: China's Secret Famine*. London: 1996./*Beyond Conflict in the Horn: The Prospects for Peace, Recovery and Development in Ethiopia, Somalia, Eritrea and Sudan*. Ed. Martin Doornbos et al. The Hague/London: 1992./Blaser, Werner. *Mies van der Rohe*. Basel: 1997./Blecher, Marc. *China Against the Tides: Restructuring through Revolution, Radicalism and Reform*. London: 1997./Bosworth, Derek, Peter Dawkins, and Thorten Stromback. *Economics of the Labour Market*. Essex, England: 1996./Brunner, Gisbert L., and Christian Pfeiffer-Belli. *Wristwatches, Armbanduhren, Montres-bracelets*. Cologne: 1999./Carter, Peter. *Mies van der Rohe at Work*. London: 1999./*Chicago Bulls Yearbook, 1999-2000*. Chicago: 1999./*Civil Society and the Aid Industry*. Ed. Alison Van Rooy. London: 1998./Cohen, Jean Louis. *Mies van der Rohe*. Trans. Maggie Rosengarten. London: 1996./*Crimes of War: What the Public Should Know*. Ed. Roy Gutman and David Rieff. New York/London: 1999./Crone, Rainer, and David Moos. *Kazimir Malevich: The Climax of Disclosure*. London: 1991./Dean, Hartley. *Poverty, Riches and Social Citizenship*. Texts by Margaret Melrose and Ruth Lister. London: 1999./De Villiers, Marq. *Water Wars: Is the World's Water Running Out?* London: 1999./Destexhe, Alain. *Rwanda and Genocide in the Twentieth Century*. Trans. Alison Marschner. London: 1995./Dowling, James M., and Jeffrey P. Hess. *The Best of Time. Rolex Wristwatches: An Unauthorized History*. Atglen, Penn.: 1996./Dreyer, June Teufel. *China's Political System. Modernization and Tradition*. 2d ed. London: 1993./*Entartete Kunst: Ausstellungführer [Ausstellung Entartete Kunst]*. Exh. cat. Munich/Berlin: 1937. Reprint, Cologne: 1988./*Encyclopedia of Rifles and Handguns: A Comprehensive Guide to Firearms*. Ed. Sean Connolly. Edison, N.J.: 1995./*The Female Odyssey*. Ed. Charlotte Cole and Helen Windrath. London: 1999./Fenton, Steve. *Ethnicity: Racism, Class and Culture*. London: 1999./Fuller, Margaret. *Women in the Nineteenth Century*. Ed. Larry J. Reynolds. New York: 1998./*La Généalogie de la morale*. Texts by Jacques Deschamps and Henri Birault. France: 1981./Greer, Germaine. *The Female Eunuch*. London: 1999./Guttsman, W. L. *Art for the Workers: Ideology and the Visual Arts in Weimar Germany*. Manchester/New York: 1997./Harland, David M. *Exploring the Moon: The Apollo Expedition*. Chichester, England: 1999./Hirschhorn, Thomas. "Casimir Malevitch" (photo copies). 1999./Hoogvelt, Ankie. *Globalization and the Postcolonial World: The New Political Economy of Development*. London: 1992./Hubbard, Jan. *Six Times As Sweet: The Official 1998 NBA Finals Retrospective*. New York: 1998./*Icons of Fashion:*

The Twentieth Century. Ed. Gerda Buxbaum. Munich: 1999./Iliffe, John. *The African Poor: A History*. Cambridge, England: 1987./Jong, Erica. *What Do Women Want? Power, Sex, Bread and Roses*. London: 1999./Khusio, A. M. *The Poverty of Nations*. London: 1999./Kier, Elizabeth. *Imagining War: French and British Military Doctrine Between the Wars*. Princeton: 1997./LaFeber, Walter. *Michael Jordan and the New Global Capitalism*. New York: 1999./Lassaussois, Jean, and Gilles Lhôte. *L'Univers des montres*. Paris: 1995./Lazenby, Roland. *And Now, Your Chicago Bulls*. Dallas: 1995. /Lesch, Ann Mosely. *The Sudan–Contested National Identities*. Bloomington/Indianapolis: 1998./Leyden, Andrew. *An After Report: Gulf War Debriefing Book*. Grants Pass, Or.: 1997./Los Angeles County Museum of Art. *Degenerate Art: The Fate of the Avant-Garde in Nazi Germany*. Exh. cat. ed. Stephanie Barron. Los Angeles/New York: 1991./Lowe, Janet. *Michael Jordan: Lessons from the World's Greatest Champion*. New York: 1999./Luxemburg, Rosa. *Reflections and Writings*. Ed. Paul Le Blanc. Amherst, Mass.: 1999./Luxemburg, Rosa. *Reform and Revolution*. Intro. Mary Alice Waters. New York: 1970./*Malevich*. Ed. José María Faerna. Trans. Alberto Curotto. New York: 1996./Marcus, Harold G. *A History of Ethiopia*. Berkeley: 1994./Marsden, Peter. *The Taliban: War, Religion and the New Order in Afghanistan*. London: 1998./Mazuri, Ali A. *The African Condition: A Political Diagnosis*. Cambridge, England: 1980./McClain, Paula D., and Joseph Stewart, Jr. *"Can We All Get Along?" Racial and Ethnic Minorities in American Politics*. Boulder, Co.: 1998./Mendes, Valerie, and Amy de la Haye. *Twentieth-Century Fashion*. London/New York: 1999./*La Montre*. Texts by Giuseppe Grazzini, Nicoletta Cabolli Gigli, and Giorgio Gregati. France: 1992./Moore, Henrietta L. *Feminism and Anthropology*. London: 1988./Nemale, Constant. *Michael Jordan: Le Livre d'or*. Paris: 1999./*Nietzsche: A Critical Reader*. Ed. Peter R. Sedgwick. Oxford: 1995./Nietzsche, Friedrich. *The Birth of Tragedy and the Genealogy of Morals.* Trans. François Golffing. New York: 1956. /Nietzsche, Friedrich. *Beyond Good and Evil*. Trans. Marion Faber. Oxford: 1998./Nietzsche, Friedrich. *The Birth of Tragedy Out of the Spirit of Music*. Trans. Shaun Whiteside. London: 1993./Nietzsche, Friedrich. *Daybreak: Thoughts on the Prejudices of Morality*. Ed. Maudemarie Clark and Brian Leiter. Cambridge, England: 1997./Nietzsche, Friedrich. *Human, All Too Human*. Trans. R. J. Hollingdale. Cambridge, England: 1996./*Non-Violent Social Movements: A Geographical Perspective*. Ed. Stephen Zunes et al. Malden, Mass.: 1999./Ovason, David. *The Book of the Eclipse: The Hidden Influence of Eclipses*. London: 1999./*The Penguin Book of Twentieth-Century Fashion Writing*. Ed. Judith Watt. London: 1999./Prunier, Gérard. *The Rwanda Crisis: History of Genocide*. London: 1995./*Race and Ethnicity in the United States: Issues and Debates*. Ed. Stephen Steinberg. Malden, Mass.: 2000./*Race, Class and Gender: Common Bonds, Different Voices*. Ed. Esther Ngan-Ling Chow et al. Thousand Oaks, Cal.: 1996./*Racism*. Ed. Martin Bulmer and John Solomos. Oxford: 1999./*Racism and Anti-Racism in World Perspective*. Ed. Benjamin P. Bowser. Thousand Oaks, Cal.: 1995./Reisner, Marc. *Cadillac Desert: The American West and Its Disappearing Water*. New York: 1987./*Rolex Oyster*. Exh. brochure. Lucerne: 1999./Romanelli, Giandomenico, and Mark E. Smith. *Splendours of Venice*. London: 1997./*Rosa Luxemburg Speaks*. Ed. Mary Alice Waters. New York: 1970./Sachare, Alex. *The Chicago Bulls Encyclopedia*. Chicago: 1999./Seidemann, *Rosa Luxemburg/Leo Jogiches*. Berlin: 1998./Sen, Amartya. and James E. Foster. *On Economic Inequality*. Oxford: 1997./*The Splendour of Venice.*

Venice: 1999./Tiffen, Mary, Michael Mortimore, and Francis Gichuki. *More People, Less Erosion: Environmental Recovery in Kenya*. Chichester, England: 1999./Toussaint, Eric. *Your Money or Your Life! The Tyranny of Global Finance*. Trans. Raghu Krishnan with Vicki Briault Manus. London: 1999./*Venice: Complete Guide to the Whole City*. Narni, Italy: 1999./*Venice: Inside and Out*. Venice: 1999./Villain, Jacques. *A La Conquête de la lune: La Face cachée de la compétition americaine-soviétique*. Montreal: 1998./Vitra Design Museum. *Mies van der Rohe: Architecture and Design in Stuttgart, Barcelona, Brno*. Exh. cat. Weil am Rhein, Switzerland: 1998./Wright, Richard T., and Scott H. Decker. *Armed Robbers in Action: Stickups and Street Culture*. Foreword by Neal Shover. Boston: 1997./Zimring, Franklin E., and Gordon Hawkins. *Crime is Not the Problem: Lethal Violence in America*. Oxford: 1997.

Essay
Disguise the Limit: Thomas Hirschhorn's *World Airport*

Hamza Walker
Director of Education, The Renaissance Society at The University of Chicago

Thinking has become increasingly difficult at airports. The placement of televisions in every possible line of sight has made it clear that undivided attention is not an inviolable right. An immediate impression of Thomas Hirschhorn's *Flugplatz Welt/World Airport* is that it re-creates the semiotic jumble of functional and commercial interests which characterizes public space at airports. Although there are clear, underlying metaphors, *World Airport* offers no overarching syntax, but rather a series of highly unstable readings and associations that render the viewer at one and the same time a late-twentieth-century Gulliver and the Incredible Shrinking Woman, made to feel simultaneously large and small before the deluge of information and the scale at which these metaphors have been realized. "Where am I?" This question is bound to arise amid the clutter of *World Airport*'s components: cellophane tendrils, partitions, lighting stands, tarmac, palisade, altars, televisions, spoons, vehicles, luggage, etc. This is an appropriate response, since Hirschhorn considers *World Airport* a map: a set of relationships established through points linked by lines and grouped together by flat planes. *World Airport*, however, is also a collage. "Much tape. Badly." These instructions, delivered as an imperative by Hirschhorn to a gallery assistant, were diligently followed to such an extent that the tape is somewhat repulsive, taking on a creeping, organic quality, a bureaucratic mildew of sorts. It transforms the gallery into a cocoon wherein certain components (televisions, chairs, the base of the partitions), having been literally collaged into or onto the space, lose their edges, becoming a monadic, undifferentiated substance at the point where they connect to the floor. The only element to reassure viewers of their coordinates in *World Airport* is what the artist refers to as the "flake of consciousness," an eerie, bright-red puddle-form that seeps out from under either side of the tarmac. Like the red dot on a map, the "flake of consciousness" is a bold declaration: "YOU ARE HERE," somewhere in this mess, somewhere on this planet.

Hirschhorn's wariness about being considered a sculptor is warranted, since modernist sculptural practices, particularly as they have culminated in airport public-art projects, have proven bankrupt. Dragging the museum's aspirations for an idealized experience of Euclidean space and form into the public realm has, by and large, been a disaster, resulting in what is commonly referred to as "plop-art," "urban jewelry," and, in the case of the airport, "homeless abstraction." It is ironic that the airport has come to

haunt the modernist gallery, which sculpture, for all practical purposes, vacated in the late 1960s with the rise of conceptual practices and public art programs. Hirschhorn's use of florescent lights shamelessly disgorges Dan Flavin's utopian aspirations for an industrially produced, commercially available, pure art and, at the same time, recuperates florescent lighting's original intent by transforming the ambiance of *World Airport* into that of "World Laundromat." Alongside the glisten and gleam of crinkled cellophane, sheets of aluminum foil, and obsessively applied packaging tape, Hirschhorn proudly submits for inspection the low production values he has flaunted throughout his work. More important, however, is what the artist's lighting signifies in relation to a public artwork such as *Thinking Lightly* (1989), Michael Hayden's blinking, neon ceiling sculpture located in the corridor between concourses B and C of the United Airlines terminal at Chicago's O'Hare airport. Hirschhorn's florescent lighting serves as a welcome antidote to what Helmut Jahn, the terminal's architect, viewed as a statement of "technological sophistication," apparently oblivious to the history of neon's crass, commercial uses in sites ranging from the most antiseptic shopping mall to the seediest urban nooks and crannies.

Hirschhorn describes *World Airport* as expressing his inability to comprehend the world, which comes together only to fall apart. He even considers the "flake of consciousness" as something of a self-portrait, representing a slice of his mind. With its holes, it certainly is not the birth of consciousness as Karl Marx would have celebrated it, but more the inadequacy of such a consciousness in the face of complex global relations that have emerged a decade after the events of 1989. In light of the break-up of the Soviet Union, the fall of the Berlin Wall, and the student uprising in Tiananmen Square, many consider the second half of the twentieth century a liberal revolution and cite as proof the transition made by a number of authoritarian regimes—large and small—from the radical left and radical right to freely elected forms of government. The sprouting of liberal democracies around the world has even lead some to conclude that we have reached the "end of history."[1] According to this theory, the birth of liberal democracy on a global scale represents the beginning of a "universal history," the narrative alignment of historical events in which liberal democracy becomes the concluding chapter of our sociopolitical evolution. Hirschhorn's decision to cast the world as an airport in tape, wood, cellophane, cardboard, plastic, and aluminum foil questions the immanence of a "universal history," especially one that serves to commemorate the current social order. Insofar as the web of flight patterns allows the globe to be grasped as a whole, one could surmise that the world is indeed an airport. But does that mean it functions as an airport?

Despite its humor, Hirschhorn's work is sad, mourning the loss of intellectual and spiritual ideals that have nourished modern utopian thought, and commemorative, celebrating the triumph of the commodity. Since Marxism had become the most comprehensive language of social transformation, "the death of socialism" became synonymous with the proscription of utopian thought as it resided in social critique. The sudden, widespread skepticism regarding historical change and social transformation mirrored the quandary in which cultural production of the latter half of this century had already found itself. Consciously and unconsciously, artists since the 1950s had been negotiating the conclusions and failure of an historical and radical avant-garde that sought social transformation. These negotiations are reflected in Hirschhorn's influences, which range from the Soviet avant-garde to Andy Warhol, from Kurt Schwitters to Joseph Beuys. Refusing

to acknowledge the historical and radical avant-garde's conclusions regarding the fate of culture in the face of implications wrought by urbanization and industrialization would leave artists little choice but to internalize and reflect the many contradictions inherent in the existing social order. This could only be done with shades of doubt, skepticism, and irony ranging from bitter to sweet. Members of Hirschhorn's generation found themselves heir to an imagination bound rhetorically by the question, "Are we there yet?" and the response, "Been there. Done that." In this respect, the avant-garde's conclusions had not been abandoned as much as they found themselves in the vice grip of irony that, throughout the 1980s, had become de rigueur. In addition the proscription of utopian thinking illustrates the extent to which such thinking had been premised on cold-war isolationism. After 1989 the future no longer belonged to an "us" or a "them," as was commonly believed during the cold war and its vigorous advancement by former President Ronald Reagan. It became an all-or-nothing proposition belonging to the entire globe. This has been made increasingly clear over the last decade, as the discourse of utopia has given way to one of globalization, a transition that casts the future in the unsettling terms of the present.

Hirschhorn's smashed-car-window aesthetic is undoubtedly a response to the conditions of a radically foreshortened future beyond which it is impossible to see. He considers his urgent, makeshift sensibility universal in scope—true at least in parts of the world where there are cars. Likewise, the tape has a painterly, expressionistic quality, signifying an urgency stylistically as commonplace as the car alarm. As with any provisional measure, the tape raises the question of time—specifically, how long before things are fixed, how long before normalcy is restored? Applied excessively, it alludes more to "the will to fix," to use the artist's words, than to actual repair and raises the issue of futility, a concept that threatens to mistakenly paint Hirschhorn as a cynic. Insofar as the artistic avant-garde can be given credit for putting forth propositions regarding the relationship between utopia and the status quo, artists throughout the century have had time to renegotiate failure and embrace the symptoms of alienation that they themselves diagnosed. The hardening of irony from Warhol to Jeff Koons is an acute example. It is precisely a gesture such as Koons's use of stainless steel—a celebratory predecessor to market liberalism's claims to global triumph—that Hirschhorn's tape and tinfoil refute. Koons's stainless-steel works, largely cast after commemoratives and tasteless promotional merchandise, achieve their clearest expression in *Kiepenkerl*, a 1987 work in which the artist relocated and recast a forgotten bronze honor-memorial sculpture in the German city of Münster. As a "new and improved" version of the same old history, Koons's recasting of the commemorative—so that bourgeois values "shine brighter and last longer"—is indistinguishable from the idea that history stands to transform itself into a providential bourgeois eternity. Obviously, Hirschhorn's work, unlike Koons's, does not adhere to the consumer slogan "Built better so you can care less." If anything it divulges the opposite, exposing stability as something of a collective myth. "The future is here!" But again, for how long?

Not surprisingly Hirschhorn is extremely sensitive about the issue of conservation, a topic to which he polemically responds, "Cardboard! Marble! What's the difference?" The difference for the artist is not eternity plus or minus ten years, but rather the aging of the world picture in terms of historical closure. The subsequent degradation and preservation of Hirschhorn's work are beside the point. Hirschhorn's process and materials

embody an a priori acknowledgment of time and, by default, change. Here, the corollary between Koons and Hirschhorn gives way to a more profound parallel between Hirschhorn and On Kawara, one that rests on their shared fetish for journalism. Kawara's serial production of date paintings and his corresponding diary practice—the *I Read* (1966) series in particular—provide a model of the linguistic subject, constituted in statements of fact (including those appropriated from journalism), that is in many ways the reductive antithesis of Hirschhorn's distracted and dispersed consciousness. Whereas Kawara's paintings and his overwhelming body of documentation challenge the viewer to rigorously reconstitute themselves in a memory as factually stark as the date, Hirschhorn's subject would seem forever solvent in the present, characterized by an overabundance of information and the inability to assemble a cogent past, let alone future.

On its surface, nothing could be further from Hirschhorn's process than Kawara's archival, serial practice. For better or worse, Hirschhorn's work is at the mercy of the world, punctuated and indeed perforated with ready-mades—the most abundant being text. Democratically selected, the texts in *World Airport* range in complexity from bumper stickers to Benedict de Spinoza. For the most part, however, the themes in *World Airport* (conflict, spirituality, commerce, philosophy) are determined by the four altars, placed at each of the work's corners, and the freestanding partitions that surround the tarmac. Ten of the partitions, those running perpendicular to the tarmac, are covered with articles focusing on a particular conflict from the past fifteen years (Kosovo, Tiananmen Square, Afghanistan, the Persian Gulf, the Falkland Islands, Israel, Sudan/Somalia, Bosnia, Turkey, and Tibet). As a mass of journalistic information, in all its sobriety and sensationalism, these partitions lack the didacticism and moral theatricality of Alfredo Jaar's work. Handwritten with a fat, black, permanent marker, the text on a group of blue partitions lists hundreds of little-known destinations without referencing the countries in which they are located, suggesting the disintegration of the world into tribes, each possessing its own airport. The allegory that immediately comes to mind here is the Tower of Babel. Our lack of familiarity with most of these places, however, begs the question "Where does globalization take place?"

Saskia Sassen has argued that globalization, despite the term's denotation, is actually a form of centralization whose key players are Berlin, Hong Kong, London, New York, Tokyo, etc.[2] If globalization is truly a matter of centralization versus marginalization, then these blue partitions can be likened to a stock-market index that registers the rise and fall of Gross Local Production which results from the competitive bartering off of natural resources and cheap labor in exchange for corporate investment. Or one could adopt the more optimistic outlook espoused by Nobel Prize-winning economist Amartya Sen: that, undeniably, quality-of-life improvements are made possible through industrial development, an argument neo-liberals often use to depict globalization as a morally righteous, "win-win situation."[3] What they do not reveal is the point spread between Wall Street earnings and the rise of per-capita income in places such as Arka, Fushun, Hubli, and Nukus combined. As for corporate winners, they appear in *World Airport* on partitions devoted to commerce, some to corporate affairs in general and others exclusively to the business of aviation.

Another partition, conspicuous for its lack of text, features a series of photographs of young, white men in sporting gear, arms outstretched, in mid-leap a few feet from the ground. There are several metaphors to be drawn here: the age-old dream of flight, an update of Yves Klein's famous photograph *Into the Void* (1960), and a celebration of individ-

ual bodily sovereignty. But the young men's age, race, and manner of dress are more suggestive of the rhetoric of rugged individualism, a symbolic freedom used to sell a lifestyle centered around sports-utility vehicles. Their aspirations prove a poor substitute for wings, and they are hopelessly backyard bound. Although the textual subject matter is determined by the partitions and altars, the dispersal of themes throughout the work generates an atmosphere of perpetual diversion. There is no beginning, no end, no hierarchy of information, and no visual respite. Since no single element in *World Airport* commands our undivided attention, all diversions are relative. Tracing the path of the cellophane tendrils, which the artist provocatively refers to as "ramifications," one would expect to arrive at a control tower that would provide an overarching syntax for *World Airport*'s individual elements. Not so. The ramifications gather at a conspicuously insignificant structure that recalls a sleepy, nonchalant Medusa's head. In the absence of a leviathan, *World Airport*'s syntax resides more in the relationship between its components than any singular element.

Despite its overwhelmingly fragmented appearance, *World Airport*, like an airport viewed from an aerial perspective, is highly ordered. The work, however, is not strictly an airport. Two of its major components are unrelated to an airport: the large aluminum-foil spoons, each measuring approximately two meters in length, spilling out from under one of the tarmac's corners; and the four altars, decorated with flowers, electric candles, garishly enlarged sneakers, and books. Hirschhorn regards the spoons and altars as critical counterpoints to the emphasis on political and commercial concerns discernible in the airport-related components. Derived from Bertolt Brecht's famous statement "First comes fodder, then comes morality,"[4] the spoons represent a materialist precondition for moral concerns—the a priori sense of caring and ethics of distribution aimed at eliminating the tension between have and have-not, between those born with a silver spoon in mouth and those suffering from hunger. The altars are dedicated to philosophy (mind), sports (body), and religion (soul), ideas that are represented, respectively, by philosophical texts (by Georges Bataille, Gilles Deleuze and Félix Guattari, Antonio Gramsci, and Spinoza,); oversized athletic shoes (Adidas®, Nike®, Puma®, Reebok®); and articles devoted to various faiths (Christianity, Buddhism, Taoism). Given the relative visual and spatial prominence of the tarmac and the adjoining partitions, the spoons and altars are at best marginalized. The diminution of ethics, philosophy, and spirituality, all branches of intellectual activity serving as guardians of transcendental and utopian longings, constitutes a marginalization of social critique.

Equally telling is the relationship between the runway diorama and the partitions featuring sites of conflict. Hirschhorn describes the former as a model of globalization built around consensus. The airplanes stand in for various nation-states and sit prepared for takeoff, receiving information from a control tower that the artist intentionally downplayed, referring to it is an "element without will," a statement reminiscent of political analyst Thomas Friedman's confounding assertion that no one is in charge of globalization.[5] The airplanes' alignment suggests harmonic convergence, the arrival of a "universal history," and worldwide accord as they take off into the sunset. This is in direct contrast to the conflict displayed on the ten, evenly spaced partitions that march along the tarmac's edge. The partitions relativize perspective, eclipsing the horizon, creating a series of stalls or gates that become claustrophobic worlds unto themselves. Consensus, conflict, and the marginalization of critique, these are as close to an overarching syntax as *World Airport* is likely to offer.

Given the nonhierarchical, diversionary character of *World Airport*, any syntax is unstable. A literal reading of one component can shift radically to a metaphorical reading of another, thereby confirming, complementing, or contradicting a previously assembled meaning. Take for instance the Dalai Lama's several appearances throughout the work: on an altar, the Tibetan partition, and the palisade. His status as spiritual, political, and popular icon cannot be reduced to a singular reading, but changes depending on the context. Another example is the inclusion of Deleuze and Guattari's *What Is Philosophy?* This text provides not simply a passage or a page but an entire chapter, "The Plane of Immanence" (plane in this instance referring to a two-dimensional surface), which serves as an uncanny description of the tarmac: "The plane [of immanence] has no other regions than the tribes populating and moving around on it. It is the plane that secures conceptual linkages with ever-increasing connections, and its concepts that secure the populating of the plane on an always renewed and variable curve."[6] As the title "Plane of Immanence" suggests, it is the ultimate common ground, whose renewed and variable curve is no doubt meant to reference the earth, whether it is considered flat or round. Incidentally, this chapter serves as a paean to Spinoza, who happens to be celebrated one altar away.

Even in the absence of such "conceptual linkages," readings of *World Airport*'s individual components still offer complex, faceted reflections capable of destabilizing an overarching syntax. The runway diorama could be considered less in abstract philosophical terms and more in terms of deregulation as it relates both to the airline industry and the relative weakness of the contemporary nation-state. Economic deregulation and the privatization of the airline industry at an international level are met with resistance from airline companies and their host nations for fear of losing "national flag status." The foreign purchase of a nationalized or state-subsidized airline threatens autonomy in pricing and routing. What exists in place of an economically deregulated market are a series of international "alliances" between airline companies. In this respect, the airline industry upholds some shred—if only that—of national interests contrary to the current discrediting of John Maynard Keynes's regulatory state and the vogue of Friedrich A. Hayek's brand of economic neo-liberalism. A related reading would identify the airline industry's complicity in the erosion of national sovereignty as rapid infrastructure development, such as the building of "international airports" in places that few recognize, is aimed at attracting investors ranging from tourists to multinational corporations. In either case, there are no clear answers. Such readings of the runway diorama, alongside the deluge of information, take *World Airport* well outside the realm of metaphor and into the realm of allegory. Never afraid to ask questions it knowingly fails to answer, *World Airport* narrates contemporary life in its complexity—the global, political economy in particular.

Suggesting *World Airport* be read allegorically, narrating a complex quotidian life, invites a comparison with the Swiss collaborative Peter Fischli and David Weiss. Executed in the late 1980s, their airport photographs serve as a seminal precursor to *World Airport*. *World Airport*, however, forces a critical rereading of not only the airport photographs, but the manner in which Fischli and Weiss' work functions allegorically. Celebrating the mundane, Fischli and Weiss' large color prints are a series in the loosest sense, mustering neither the concern of social documentary, nor the formal rigor of New Objectivity. Their runway and gate scenes are casually framed and kept to a bland, middle-ground distance that resists glorifying the airport. Since the works provide no other distinguishing charac-

teristics of place, beyond an occasional glimpse of greenery at the tarmac's edge, they propose that the world is an airport, linked by a series of homogenous and homogenizing terminals, fuselages, gates, and runways. Like the allegorical model of historical change in their 1986/87 video *The Way Things Go*, which uses mundane materials à la Rube Goldberg to narrate a grand scale of sociopolitical activity, the airport photographs rely on the veracity ascribed to a snapshot. Fischli and Weiss' deployment of allegory through tepid documentary and, in their earlier work, through staged photographic practices, does not result in a tautological relationship in which simple objects are used to tell simple stories. Their use of allegory converts myth into the mundane and the mundane into myth. In this instance, the myth being that the world is an airport. But does the world function as an airport? For Fischli and Weiss, the answer seems to be yes. Clearly, Hirschhorn begs to differ. For him the proposition and answer are not necessarily synonymous. In light of *World Airport*, Fischli and Weiss' work resigns itself to a state of affairs that is never really seen or questioned. Beneath its humility is the foregone conclusion that this is indeed the way things go. Hirschhorn constructs only to dissolve and hopefully to challenge such myths by drowning his crude artistic production in a mass of contradictory, ready-made information, an acknowledgment that an attempt to form a narrative or narratives of globalization at the level of allegory is bound to fail. It is a conclusion similar to that of artist Allan Sekula, whose *Fish Story* (1990–95) uses social-realist documentary photography to narrate globalization through the all-but-forgotten story of the world's seaports.

Hirschhorn's practice, however he may choose to define it, has been grounded in the face of a burgeoning e-world that threatens to mask concurrent and concrete social realities. "Cardboard! Marble! What's the difference?" Everything, when it comes to signifying a consciousness unable to comfortably resign itself to the premature "end of history," and nothing, without an imagination fueled by thoughts as to what the world could be, for better or worse. Whereas the age-old dream of flight served as a metaphor for the unbound imagination, the skies are now bound with the vapor trail of each and every jet. Looking up, we want to see ourselves, and we do. The sky is still the limit. But neither technological achievements and the subsequent riches they bring to too few, nor the immediate local conflicts and the strife they bring to too many should disguise the limits regarding moral, material, and spiritual progress. A better world nowhere, now here, or perpetually elsewhere? That remains the question.

Notes

Unless otherwise noted, all quotes from Thomas Hirschhorn are from correspondence or conversation with the author.

1. Francis Fukuyama, *The End of History and the Last Man* (New York, 1992).

2. Saskia Sassen, *Globalization and Its Discontents: Essays on the New Mobility of People and Money* (New York, 1998).

3. Amartya Sen, *Development as Freedom* (New York, 1999).

4. Bertolt Brecht, *Die Dreigroschenoper* (Berlin, 1928).

5. Thomas L. Friedman, *The Lexus and the Olive Tree: Understanding Globalization* (New York, 1999).

6. Gilles Deleuze and Félix Guattari, *What Is Philosophy?*, trans. Hugh Tomlinson and Graham Burchell (London, 1994).

Interview

Interview between Okwui Enwezor, *Adjunct Curator of Contemporary Art, Department of Modern and Contemporary Art, The Art Institute of Chicago* and Thomas Hirschhorn, January 5 – 6, 2000

Okwui Enwezor (OE): *I would like to begin by asking whether you think that the year 1994, or more precisely, the exhibition of your work at the Jeu de Paume, Paris, marked a turning point in your work between the formal, sculptural syntax you developed in the early 1990s and work you are doing today.*

Thomas Hirschhorn (TH): No exhibition has been a turning point in the development of my work. I have always envisioned my work as a series of positions taken. I realized for the first time that what I do was really being discussed after the exhibition at the Jeu de Paume. Showing my work there did not create a rupture with what I had been doing before. What mattered to me was that many, many people saw my work for the first time.

OE: *Given that your previous work was concerned with the interaction of the work on the street, and here the work was presented in the museum context, would you say that the relationship changed in terms of the work's reception in a public context? Did you not like the ways in which the work was discussed in this prior context?*

TH: What must be said is that I never exhibited my work exclusively in the street and then exclusively in a museum. Before the show at the Jeu de Paume (which is not really a museum but a national gallery), I exhibited my work in diverse settings: in the street, in galleries, in art centers, in alternative spaces. For me this exhibition meant an extension of the field in which I work. I think that the artwork itself is important, that context cannot change a work. I believe in the autonomy of the artwork. The interesting thing about showing in a museum is that the audience comprises both people who know about art and those who are just passing by, as in the street, except in different proportions.

OE: *Talk about the transition from the life of the work in the street—and the ways things appeared in the street—to a regimented presentation that, in many ways, affects the formal qualities of the work itself. Where, would you say, was the critical transformation in the work's appearance?*

TH: I want to make the same kind of work everywhere. What interests me is to make work that exists as well in one type of setting or another, in public as well as private space. I never ask myself what I can take from the street into the museum. But I do ask what I can take from the museum out to the street. I want to make work that is not hierarchical, that does not isolate, that does not intimidate. I want to make work that must fight to exist no matter where; work that has never found its place.

OE: *Where would you say the notion of hierarchy is dissolved in your work, especially in terms of the content of your intervention in whatever space in which the work is presented? Or does the notion of not establishing hierarchy affect your interventions into those spaces in which you chose to work?*

What really changes the nature of the work in the relationship between the point of its presentation and its public reception?

TH: The attention given to my work ranges from total rejection to total absorption, and this is in the street as well as in the museum. The work does not change, whether one pays attention to it or not. This is something essential in art: reception is never its goal. What counts for me is that my work provides material to reflect upon. Reflection is an activity.

OE: But what would you say to the idea that one creates a kind of democratic space in which the work exists, an alternative, public sphere around which the notion of sculpture of this nature—and its utter fragility—can be constituted in a democratic sense?

TH: I want to make non-hierarchical work in non-hierarchical spaces. The work is not something more in the museum and something less in the street: this is essential for me. I am concerned by equality and inequality in all forms. Thus, I do not want to impose hierarchies; in exhibiting my work, I try to efface the values associated with the location of the exhibition. I am not interested in prestige. I am interested in community. Democracy is a beautiful concept, but I think democracy and direct democracy are becoming increasingly passive; they are terms that dissimulate. Democracy can conceal private interests. I want to replace the word democracy with equality.

OE: It seems to me that the spectator is really at risk inside of your installations. There is a massive amount of information they must process in order to arrive at that crucial nexus of meaning you may want to connect them to. So what sense of power do you give the spectator when the sheer amount of information you throw at them becomes overwhelming? Is there a position you take in terms of how the spectator confronts your work?

TH: I do not wish my work to exclude anyone; I try to create for people the possibility of entering into my work in different ways, introducing elements that provide access (the Chicago Bulls and Rosa Luxemburg spoons are examples). I want to be precise but open. I do not want to invite or oblige viewers to become interactive with what I do; I do not want to activate the public. I want to give of myself, to engage myself to such a degree that viewers confronted with the work can take part and become involved, but not as actors. When I present an abundance of images, documents, and informational materials, I try to demonstrate that, on their own, these things are important not because I have selected them and made them evident by enlarging them, but because their importance can be judged differently from one person to the next.

OE: In the past, you vehemently refused to classify or constitute your work as installation, choosing instead the notion of sculpture to describe the spatial practice of your work, its presence in a given space. But there is an evident paradox in the idea of sculpture being part of the condition of your work, in that sculpture's formal terms can be seen today as the very antithesis of radical, progressive thinking. How do you reconcile this paradox between the utterly conservative nature of sculptural practice, with its formal, canonical essence, and the work you make today? Why this distinction between sculpture and installation in your work?

TH: As an artist, I don't think that I have to resolve paradoxes and contradictions or to fight confusion; I myself feel confused and full of contradictions. I make affirmations without being certain of their validity. But I must work according to what interests me profoundly. What I reject in the word "installation" is that it is a term that reduces work to a form of expression. It is an insider, contemporary-art term. I do not make work that achieves within a form, within a discipline; I think that those who use the term "installation" to differentiate this genre from painting, video, photography, etc., are lazy, because they believe that the decision to work in one or another medium is a formal choice. I have never said "I want to make an installation." An artist who uses photography as a medium is not a photographer. Artists make their work in the most appropriate way to convey what they wish to say. I call my work "sculpture" because it is an open term. I achieve in three dimensions what I have thought out in two dimensions: I think in plans, points, and lines. This kind of thinking is stacked up. I have to work my ideas out in space. That transformation is a sculpture without volume, without thinking of making volume. I don't think that the term "sculpture" is anti-progressive or anti-radical. I think of the work of Joseph Beuys.

OE: *It seems to me that we can go from this paradox—the distinction you make between sculpture and installation—into the very nature of another contradiction, which is sculpture's relationship to the monument. The monument has been very much a part of the way that you not only describe the public presence of the personalities you admire, but also serves to critique the very constitution of the monument as a forever-present, temporal question in the public imagination. How do you reconcile your critique of the monument, which you insist upon relative to the specificity of a given work, as conditioned by the language of sculpture, and the fact that you do not wish to produce monuments?*

TH: My critique of the "monument" comes from the fact that the idea of the monument is determined, produced, and situated by decisions imposed from above, by those in power. And its forms correspond to the will to lead people to admire the monument and, along with it, the dominant ideology—whether it is the monument in Berlin to Ernst Thälmann, cofounder of the German Communist Party, or the commemoration in Washington, D.C. of those who lost their lives in Vietnam. A monument always retains something of the demagogic. I want to fight hierarchy, demagogy, this source of power.

OE: *Of course the nature of the materials you use has been central to the discussion of your work in recent years, especially your proclivity for and insistence on materials that are readily available, cheap, mass-produced; materials that both mimic "kitsch" and deride the excesses of our throw-away, consumer-driven culture. For me there is, in this choice of cheap, quotidian materials such as plastic, aluminum foil, and cardboard, a strategy to contaminate the very nature of art's relationship to high culture, and to critique the preciousness of sculptural practice. What led you to these types of materials for your work?*

TH: The choice of materials is important. I want to make simple and economical work with materials that everyone knows and uses. I don't choose them for the value of their appearance. I hate art made of noble materials. I don't understand why one attaches value to a material, whether it is clean metal, marble, glass, fine wood, big screens, empty space, and enormous, heavily framed objects, etc. I don't believe these are contemporary expressions. I

am against using materials or forms that attempt to intimidate, seduce, or dominate rather than encourage reflection. For the activity of reflection, material does not matter. The materials I work with are precarious. This means that their temporal existence is clearly determined by human beings, not by nature.

OE: *Don't you risk, in terms of the materials you use, the charge of being patronizing to so-called everyday people in terms of this idea of working very close to how "people" identify, through their sense of recognition, what these materials are and what they mean? In a sense, [don't we have here] what one would call a kind of naïve utopianism and a nostalgia, a kind of social-realist attitude, about the humility of such materials versus the pretensions of high art—the highly finished, regulated, and precious sculptural object in a museum context and the banal, unprecious material of the everyday.*

TH: My choice of materials, as well as my work itself, is constituted as critical, obviously. The energy that fuels my work comes from my being a critic of the state of the world, of the human condition. However, for me these choices are based on a determination that originates beyond classification of the order of making critical art. I don't want to play the critic against the public or vice versa; but, rather, art and the art world cannot be removed from the larger world. I try to present my ideas and reflections in a clearer, more powerful manner at each exhibition. Naïveté doesn't interest me; utopianism does; nostalgia doesn't interest me; stupidity does. I want my work to be judged.

OE: *Yet there is still the risk of the work being seen as "radical chic," because it so clearly references attitudes sympathetic to a quasi-democratic context of art for the populace rather than for the elite.*

TH: To make art is very risky. But terms such as "radical chic" make me really angry. I believe that this term comes from the fashion element of the art world. It is a critical term that protects its own interests, the real chic. "Radical chic," like "politically correct," is an art-world term that, as such, is an ineffectual and uninteresting phenomenon of our time. These terms reflect fleeting values and are used to avoid rather than initiate discussion.

OE: *I understand your refusal to have your work contained in this particular register, even though writers critiquing it find that certain aspects are consumed by an overly stylized fashion, which is neither the work's fault nor intention. But I want to depart from that and go on to what has been one of your central preoccupations, the political nature of your artistic enterprise—that you do not make political art but that you make art politically. What does this mean?*

TH: Political questions are life questions. They are not art-specific or ideological. I want to affirm, as strongly as possible, that my art must appropriate the world. To make art politically means to choose materials that do not intimidate, a format that doesn't dominate, a device that does not seduce. To make art politically is not to submit to an ideology or to denounce the system, in opposition to so-called "political art." It is to work with the fullest energy against the principle of quality.

OE: *Your work has also been concerned with the hyper-capitalist, multinational rhetoric of globalization, especially as seen in your recent* World Airport, *shown first at the 1999 Venice Biennale and then*

at The Renaissance Society at The University of Chicago. What is it specifically about globalization that troubles you and that warrants the extensive inquiry you submit it to in your projects?

TH: In my view, there are complicities between globalization and what I call "macro-isolation." There is a link between these two forces, which tend to go in opposite directions but which finally meet by profiting from each other. Globalization, communication everywhere and all over, economic forces, worldwide enterprises all become increasingly closer and unified. The world grows smaller. Macro-isolation, self-isolation, and particularities—ethnic, religious, social, linguistic, cultural, etc.—local divisions, regional and private wars, war lords all tend to separate one entity from another. This shrinkage and splitting is what I wished to explore in *World Airport*.

OE: Let's return to the personalities that have become a part of your personal mythology. You have created in your work a kind of encyclopedia, a cosmos, in which the works and ideas of a number of twentieth-century artists and writers have been made to resonate. Out of this, you have elaborated upon four sculptural models to investigate such issues as loss, love, piety, ideology, and so on. They are: altars, monuments, "Direct Sculptures," and kiosks. You have made these over the past three or four years. What is it about these individuals that attracts you to them?

TH: What matters most to me, in choosing these individuals, is that they have all tried to change the world. They have all led lives and produced work that inspire admiration, not in terms of success or failure, but through the pertinence of their inquiry. I can say that I love them and their work unconditionally. I love Robert Walser, Ingeborg Bachman, Gilles Deleuze, Benedict de Spinoza, Otto Freundlich, Fernand Léger, Emmanuel Bove, Ljobov Popova, Piet Mondrian, Georges Bataille, Raymond Carver, Emil Nolde, Gramsci, and Meret Oppenheim.

OE: So it is their personal investment or engagement, rather than their embodiment of a higher ideological position, that moves you?

TH: Yes, the commitment is personal. The fact that I say I love these artists and writers and put them in a public place is a personal, artistic commitment on my part.

OE: And so you see the monuments as placed in the service of their political and ethical positions?

TH: Yes.

OE: Let's go back to the question of the altars, and your motives for making them.

TH: I made four altars, each for someone whose work is important to me and who is deceased: Mondrian, Bachman, Freundlich, and Carver. All of these altars commemorate their lives and work, and are situated in locations where they could have died by accident, by chance: on a sidewalk, in the street, in a corner. I exhibited all four altars in different cities; two have been shown twice in different places. These very local sites of memory become universal sites of memory, by virtue of their location. The altars evoke the memory of someone who has died and who was loved. It is important to attest to one's love, one's attachment. My

altars were inspired by the memorials that are created spontaneously for the deceased, both famous and anonymous.

OE: *But the altars are dislocated, shown out of context and in places where we least expect them.*

TH: What interests me in working in public spaces is the choice of placement, of location. The spontaneous altars to which I just referred are in unexpected locations. Most people don't die in the middle of a square or on a beautiful boulevard; their death, or the accident that precipitates their death, rarely happens in a strategic place. Even famous people do not die in the center of something. There are no hierarchies involved. Location is important not in relationship to the plan of a city but in relationship to the deceased. This is how I locate my altars.

OE: *I want to shift to the four sculptural categories that you have developed in terms of the ways in which you are seeking a kind of interaction within the context of public space, without ever emphasizing the public [aspect of the] space as one of the conditions of the work. What does "Direct Sculpture" mean to you and how does it relate to your work overall?*

TH: "Direct Sculptures" are models of monuments. They are in contrast to altars, kiosks, and monuments, located in interiors, in exhibition spaces. "Direct Sculpture" is the coming together of a will that issues from below and a will that issues from above. This congruence gives shape to a new type of sculpture, a three-dimensional form that lends itself to carrying, to supporting messages that have nothing to do with the original purpose of the actual support. The message takes possession of the sculpture. My first "Direct Sculpture" was inspired by what happened in Paris at the spot of the automobile accident that killed Princess Diana. At this location, a monument exists which represents the flame of liberty. Because of the princess' death, this monument, which had been standing unnoticed for years, took on new meaning. People started using it as a support for their messages of love to the princess. They have claimed the monument, transforming it into a just monument.

OE: *But, in this sense, "Direct Sculpture" also plays off the syntax of the ready-made.*

TH: "Direct Sculpture" has no signature. It is signed by the community, with colored spray paint, or whatever. In this sense, it is not a ready-made.

OE: *You have made what you call classical monuments for four philosophers: Spinoza, Deleuze, Gramsci, and Bataille. Why them, and why monuments for them and altars for artists and writers?*

TH: These philosophers have something to say to us today. I think that the capacity of human beings for reflection, the ability we have to make our brains work, is beautiful. Spinoza, Deleuze, Gramsci, and Bataille are examples of people who instill confidence in our reflective capacities. They force us to think. Monuments to their memory continue to question, reflect, and keep this internal beauty vital. The altars for artists and writers are conceived as personal commitments; the monuments for philosophers are conceived as communal commitments.

OE: *You have stated that artists have a responsibility in the ways their work communicates with the world. What do you see today as the ethical relationship between contemporary art and artists working today?*

TH: **Spaces that contemporary art occupies are spaces for reclaiming the world, which I believe contemporary art must do. As an artist, I want to work in relationship to and in the world that I inhabit. Contemporary art is a strong force, because it can repossess the world according to the biases of individual commitments. It poses the question of ethics. It can express sadness; it can express what we reject.**

OE: *Recently, you made a wonderful sculpture, or installation, for "Mirror's Edge" (Umeå, Sweden, Bildmuseet), an exhibition I curated, in which you played with an utterly melancholic sensibility. It interests me that, in certain ways, your work can be seen as melancholic and, at the same time, very aggressive. The piece in "Mirror's Edge" played with all sorts of conditions: hot and cool, changes in perception, mirroring of ideas. This produced an affective reality, a sort of fictional space, something you called a* Critical Laboratory. *I am interested in the interdisciplinary nature of your work, in your desire to connect things that cannot connect. What is your motivation in seeking such seemingly impossible connections?*

TH: **To connect those things that have nothing in common is one aspect of my work as an artist. I can do this, give physical form to a gathering or connecting of things that is intellectually impossible. To connect what cannot be connected, this is exactly what my work as an artist is. In *Critical Laboratory*, I tried to give space, form, and even time to the very complex mechanism by which I make a critical judgment about something, in response not to a specific question but to the totality of questions about everything. That makes it strange.**

OE: *Your sculptural language evokes works by other contemporary artists: Pascale Martin Tayou, Bjarne Melgaard, Georges Adeagbo, Jason Rhoades. On the surface, their works and yours seem to relate in terms of such concerns as spatial arrangement, disembodiment, accumulation, or fragmentation. This might suggest a kind of sculptural style that is prevalent in the art of the 1990s. Do you see a relationship here, and if so, are you working within this style as a way to critique it as a style?*

TH: **I am not a chaotic artist. I want to work in a space with fragmentation, broken scales, multiplied angles, and to put a very strong light on what is suspect. I am against work of quality, ready-mades, finished products. I try to work with total energy. Energy, yes! Quality, no! If this relates my work to that of other artists, it's not because we share a style; rather, it's because we all reject quality. I believe only in energy.**

OE: *It seems clear that your affirmation of the handmade enlarges the possibilities for the public to experience your work. There is a sense of irony in the kind of enlargement you make of quotidian objects, rendering them as soft sculptures on the verge of being constituted into finished objects or trash. Do you see a contradiction in placing an ironical presentation of everyday objects before the public?*

TH: **The irony comes after the work has been made. It is self-irony. It is not cynical. I am not interested in applied arts. If I create handmade works, it's so that the process of blowing up**

becomes visible. It's not about craft or technical prowess but rather about the result of intentionally taking the measure of things. I am interested in the out-of-time procedure. A worker who makes large signs or symbols in order to show them in a demonstration is not involved in a hobby. A soccer fan who holds up a big, handmade trophy cup in order to cheer on his team is not interested in hobbies. But each of them has a will, and they express it, without caring if it is anachronistic. I think as well about the carts made for street parades and carnivals. What I like is all the energy, I'd even say love, that goes into the making of such objects. I'm not interested in the banality of all that, but rather in the complexity of that, of its relationship to life.

OE: *How do you see your work operating in the ideological construct we conceive of as public space?*

TH: To date I have made thirty-four interventions in public spaces, which are places for everyone. Public space is only public. Private space is not only private. Some spaces are more private than others. There are people without a private space. That is why to act in public space is a proposition that enlarges a possible audience. Also, the experience of time changes when you move from a private to a public space. There is nothing private about time. Public space means confrontation. To exhibit in public space is cruel, but public space is just.

OE: *At the same time that your work is concerned with humble, mass-produced materials, you are very interested in the city, specifically in the marginal aspects of city life. Margins, after all, indicate the existence of a center, of institutional power that denies and creates the marginal. Can you speak to this issue?*

TH: My work is tied to the city in that this is where people live, where they derive their energy, where they confront themselves, and where there is space for art to conquer. When I think "city" or "inner city," I don't think of center, for the center no longer exists. I think of the energy of the periphery or margin, between center and edge, the difference between engagement in the center and at the edge. In my work, I try to find pragmatic reasons for interventions that go beyond the concept of center/edge. The center is wherever people live. That's where I want to work.

OE: *Are you contesting the idea that there is indeed a center?*

TH: In my work, there is never a center. It is constituted of different elements. I do not think that art has a constituted center; it's an open space. Art makes things move and keeps thoughts moving; it decentralizes.

OE: *How do you choose the sites in which your work exists?*

TH: I have the liberty to chose the public spaces in which I would like to put my work. This choice is primary; rather than selecting a fine, sophisticated spot—a central location filled with historic resonance tying the space to the city, a contextual space—I look for a place that relates specifically to my project, and also that permits my work to be mobile, in another city,

in another country. These locations are places of passage. I try to work where people go for reasons other than artistic ones.

OE: *The piece you made for the Solomon R. Guggenheim Museum, Soho,* VDP—Very Derivated Products, *struck me in terms of its aggression toward the institutional space and the ways in which it tried to contaminate that space by inviting the outside space to infiltrate the structure. It reconceptualized the tension between the socially constituted public sphere and the institutionally constituted sphere in which culture and commerce merge. Why this particular site for this work?*

TH: **For this project, I chose the museum store, which sells cultural objects, more than informative documents about artists' work and projects. I chose it because it demonstrates the problematic situations between information, admiration, and the way culture introduces "added value." In this shop, you can buy teacups and umbrellas decorated with artists' signatures. You don't have to buy books about artistic reflections and positions that make one think about art. You just buy culture! I also chose this place because, in order to go to the museum, you have no choice but to walk through the shop. I tried to place my work in the most difficult and least gratifying space, but at the same time it was the only location that was public, visible twenty-four hours a day, seven days a week.**

OE: *Your work possesses the attributes of a work in progress, a studio, a laboratory, a storage space; all are evoked in the experience of walking through them. Can you discuss how the movement in your work between these associations becomes a kind of evasion, as if no one sphere, or context, determines the way one sees what you do?*

TH: **Art is always movement, art is work. I hate forms and formalisms that wish to impose themselves on us as something fixed, stable, immutable. I want my work not to make one think first about art, but rather about something related to other work or life experiences. Laboratory, storage, studio space, yes, I want to use these forms in my work to make spaces for the movement and endlessness of thinking and to provide time for the movement of reflection.**

OE: *I am intrigued by your notion of yourself—seemingly anachronistic in this age of global capitalism—as a worker. You refuse to see your work as a piece, because of the market appropriation of a piece as a product. You emphasize the notion of the work as conceived of not only through the ideas of the artist but in the very activity [involved in the] production of it.*

TH: **I love the word "work." It indicates both something realized and an action. I also love that the word relates the activity of an artist to that of a secretary or a baker, and so forth, in the sense of something that must be accomplished, done. Production does not come from productivity; rather, it comes from having given form to an idea; it is in this sense that I try to work. There is a sense of resistance in the word "work" and also in the activity of work. Both noun and verb fight against "producing a piece," which is the opposite of what I want to do.**

OE: *Let's discuss the interdisciplinary nature of your practice. You were trained as a graphic designer, a training that manifests itself in the orientation and arrangement of your work. Moreover, you work*

with writers who contribute commentaries about your ideas. You are a worker, an artist, a philosopher, a writer, and a researcher. How do these disparate identities converge in your work and become legible as an idea or a fully constituted process of sculptural elaboration?

TH: I am an artist, worker, soldier. I am neither a theoretician nor a philosopher. At first I wanted to be a graphic designer with a political commitment because of what I could achieve with social issues and in everyday life. Such political thinking, I understood after some time, is limited because such work only serves an ideology. I was not interested in making graphic design for an ideology. I wanted to give form to things that revolted me, that I could understand, that I did not agree with. But I wanted to give them my forms. That is how I decided to be an artist. My work with several writers, Manuel Joseph, Jean Charles Massera, Marcus Steinweg, comes from the fact that I share their concerns about the use of words to appropriate the world. Also because I want to include people who are not interested in the formal aspects of contemporary art, but are open to ideas expressed through writing or to writing in general. I want to integrate their work into mine just as they integrate mine into theirs.

OE: *You often say that art has an ethical purpose. How do you reconcile this with the current critique of political correctness and multiculturalism?*

TH: The motor that drives my work is the human condition and my concerns about it. I do not believe that the process of making art can exist without taking a critical position. An artist does not make a work of art so that it works or succeeds. To not agree with the system requires courage. Artists are disobedient—this is the first step toward utopia. An artist can create a utopia. The utopia is based on disagreement with predominant and preexisting consensus. I want to work freely with what is my own.

OE: *I want to end this interview with your current work at The Art Institute of Chicago. There seem to be some scatological elements connected with* Big Cake, *especially in the etymological meaning you allude to between "cake" and "kaka." Part of your proposal is to cut the cake into twelve equal parts. In this gesture, you seem to be speaking about the distribution of resources in global economic terms. The spoons, meanwhile, represent failed utopias. I am fascinated by the ease with which you have conflated individual movements and structures as part and parcel of what a failed utopia is. How are the Chicago Bulls and the moon failed utopias?*

TH: I had to make twelve spoons, and I wanted the spoons to refer to things that don't engage me, like the Chicago Bulls spoon, Rosa Luxemburg spoon, and Friedrich Nietzsche. In selecting them, I opened possible doorways between them. Perhaps Miss Luxemburg goes to see the Chicago Bulls. She does not have only one focus, preoccupation, or love; she is perhaps aware of her contradictions, or she is confused. That is why I put the twelve spoons together. I am interested in the interaction and links between them. The links are the failures, the failures of utopias. A utopia is something to aim for, a project, a projection. It is an idea, an ideal. It is right; it is wrong. Art and making artwork are utopian. But a utopia never works. It is not supposed to. When it works, it is a utopia no longer.

Exhibitions

Thomas Hirschhorn
Born Bern, Switzerland, 1957
Studied at the Schule für Gestaltung, Zürich, 1978–83
Lives and works in Paris

Selected One-Person Exhibitions

1986	Paris, Bar Floréal
1987	Cologne, Kaos-Galerie
1991	Bern, Galerie Francesca Pia
1992	Paris, L'hôpital ephémère, "233 travaux, Jeudi 17.1.1991–Jeudi 28.2.1991"
1993	Dijon, Fondation art et société, "Hommage à Edouard Manet: Thomas Hirschhorn, Adrian Schiess"
	Bern, Galerie Francesca Pia, "Flying Boxes"
	St. Gallen (Switzerland), Galerie Susanna Kulli, "Lay-Out"
	Lucerne, Raum für aktuelle Kunst, "11 vernagelte Fenster"
1994	Basel, Filiale Basel, "Rosa Tombola"
	Brussels, APP BXL, "99 Sacs plastiques"
1995	Fribourg (Switzerland), Fri-Art, Centre d'art contemporain, "Très Grand Buffet"
	Frankfurt am Main, Strauss & Adamopoulos, "Buffet"
	Berlin, Künstlerhaus Bethanien, "Berliner Wasserfall mit Robert Walser Tränen"
	Geneva, Centre Genèvois de gravure contemporaine, "Les plaintifs, les bêtes, les politiques"
1996	Antwerp, The Hal, "Stand"
	Berlin, Galerie Arndt & Partner, "Virus-Ausstellung"
	Bilbao, Institut français de Bilbao, Salle Rekalde, Area 2, "WUE–World Understanding Engine"
	Lucerne, Kunstmuseum Lucerne, "Thomas Hirschhorn, Günter Förg"
	St. Gallen (Switzerland), Galerie Susanna Kulli, "Aptropfmaschine, Ruheraum mit Tränen"
1997	Bordeaux, FRAC Aquitaine, "Lascaux III"
	Bremen, Galerie im Künstlerhaus, "Diorama"
	Paris, Galerie Chantal Crousel
	Zürich, Kunsthof, "7/7, 24/24, Blauer, schwebender Raum"
1998	Bern, Kunsthalle Bern, "Swiss Army Knife"
	Cologne, Museum Ludwig, "Rolex, etc., Freundlichs 'Aufstieg' und Skulptur-Sortier-Station-Dokumentation"
	Frankfurt am Main, Portikus, "Ein Kunstwerk, ein Problem"
	Herzliya (Israel), Herzliya Museum of Art, "Swiss Converter"
	London, Chisenhale Gallery, "World Corners"

1999 Berlin, Galerie Arndt & Partner, "Bernsteinzimmer"
Paris, Galerie Chantal Crousel, "Sculpture Direct"
Luxembourg, Galerie Erna Hécey, "Sculpture Direct II, III, IV, V"
Zürich, Universität Zürich-Irchel, "Robert Walser Kiosk" and
 "Ingeborg Bachman Kiosk"

Selected Group Exhibitions

1989 Bobigny (France), Hôtel du conseil général, "Babylone Bobigny"
1991 Fontenay-sous-Bois (France), Salon d'ephémère
1992 Zürich, Shedhalle Zürich
1993 Montreuil-sous-Bois (France), La Zonmééé, "Arrêt sur image 3"
Paris, "Rencontres dans un couloir no. 1"
1994 Munich, "Europa 94"
Paris, Galerie Nationale du Jeu de Paume, "Invitations"
1995 Bordeaux, "Shopping"
Johannesburg, "Africus: First Johannesburg Biennale"
1996 Limerick (Ireland), EV + A
Metz-Borny (France), FRAC Lorraine, "Actions urbaines"
St. Nazaire (France), XIIèmes Ateliers du FRAC des Pays de la Loire
1997 Biel (Switzerland), Centre PasquART, "Nonchalance"
London, Camden Arts Centre, "Parisien(ne)s"
Münster, "Sculpture. Projects in Münster 1997"
Paris, ARC/Musée d'art moderne de la Ville de Paris, "Delta"
1998 Basel, Kaskadenkondensator, "Nonlieux"
Berlin, First Berlin Biennial, "Berlin/Berlin"
New York, Solomon R. Guggenheim Museum (Soho), "Premises: Invested Spaces
 in Visual Arts, Architecture, and Design from France, 1958–1998"
Minneapolis, Walker Art Center, and Chicago, Museum of Contemporary Art,
 "Unfinished History"
Zürich, Kunsthaus Zürich, "Freie Sicht aufs Mittelmeer"
1999 Amsterdam, St. Annenstraat Project, "Midnight Walker and City Sleepers" W139
Maastricht (The Netherlands), Bonnefanten Museum, "Provisorium I:
 Five Potential Acquisitions"
Paris, Galerie Yvon Lambert (Côte rue), "Ma Sorcière bien aimée"
Venice, "'dAPERTutto' La Biennale di Venezia. 48a Esposizione
 internazionale d'arte"
Zürich, Kunsthaus Zürich, "Weltuntergang & Prinzip Hoffnung"
Umeå (Sweden), Bildmuseet, "Mirror's Edge"

Bibliography

Birnbaum, Daniel. "Practice in Theory." *Artforum* 38, 1 (Sept. 1999), p. 154.

Bonami, Francesco. "Thomas Hirschhorn" in *Cream: Contemporary Art in Culture: 10 Curators, 10 Writers, 100 Artists*. London, 1998. Pp. 180–83.

––––––. *Unfinished History*. Exh. cat. Minneapolis: Walker Art Center, 1998. Pp. 24–25, 86–87 (illus.).

Buchloh, Benjamin H. D. "Sculpture Projects in Münster." *Artforum* 36, 1 (Sept. 1997), pp. 116–17.

Cologne, Museum Ludwig. *Rolex, etc., Freundlich's 'Aufstieg' und Skulptur-Sortier-Station-Dokumentation*. Exh. cat. with text by Marcus Steinweg. 1998.

Cuvelier, Pascaline. "City of Slights." *Artforum* 36, 3 (Nov. 1997), p. 49.

––––––. "Weak Affinities: The Art of Thomas Hirschhorn." *Artforum* 36, 9 (May 1998), pp. 132–35.

Fibicher, Bernhard, and Max Wechsler. *Swiss Army Knife*. Exh. cat. Bern: Kunsthalle Bern, 1998.

Frankfurt am Main, Portikus. *Thomas Hirschhorn: Ein Kunstwerk, ein Problem*. Exh. cat. with text by Angelika Nollert, trans. Fiona Elliot. 1998.

Gingeras, Alison M. "Cheap Tricks—Hirschhorn's Transvaluation Machine." *Parkett* 57 (Dec. 1999), pp.134–36.

––––––. *Thomas Hirschhorn*. Exh. cat. London: Chisenhale Gallery, 1998.

––––––. "Thomas Hirschhorn: Striving to Be Stupid." *Art Press* 239 (Oct. 1998), pp.19–25.

Gingeras, Alison M., Manuel Joseph, Marcus Steinweg, and Stéphanie Moisdon Tremblay. *Flugplatz Welt/World Airport*. Exh. brochure for "'dAPERTutto' La Biennale di Venezia. 48a Esposizione internazionale d'arte." Venice, 1999.

Hanru, Hou. "Thomas Hirschhorn." *Flash Art* 192 (Jan.–Feb. 1997), p. 88.

Hirschhorn, Thomas. "Thomas Hirschhorn" in *"dAPERTutto" La Biennale di Venezia. 48a Esposizione internazionale d'arte*. Exh. cat. Venice, 1999. Pp. 128–31.

Janus, Elizabeth. "Thomas Hirschhorn, Kunsthalle Bern." *Artforum* 36, 5 (Jan. 1998), p. 46.

Jouannais, Jean Yves. "Thomas Hirschhorn: Wagering on Weakness." *Art Press* 195 (Oct. 1994), pp. 56–58.

––––––. "Invitations." *Art Press* 192 (June 1994), pp. 18–19.

Kuni, Verena. "The Big Issue." *Frieze* 45 (Mar.–Apr. 1999), p. 59.

Madoff, Steven Henry. "All's Fair." *Artforum* 38, 1 (Sept. 1999), pp. 145–54, 184.

Münster, Westfälisches Landesmuseum. *Sculpture. Projects in Münster 1997*. Exh. cat. ed. Klaus Bußmann, Kasper König, and Florian Matzner. 1997. Pp. 210–17.

Reust, Hans Rudolf. "Thomas Hirschhorn." *Artforum* 36, 5 (Sept. 1996), pp. 118–19.

Steinweg, Marcus. "Reason in Conflict—The War of Différance II." *Parkett* 57 (Dec. 1999), pp. 145–47.

Storr, Robert. "Art Carnies." *Artforum* 38, 1 (Sept. 1999), p. 146.

Vergne, Phillippe. "Thomas Hirschhorn, You Are So Annoying." *Parkett* 57 (Dec. 1999), pp. 138–41.

Illustration Checklist

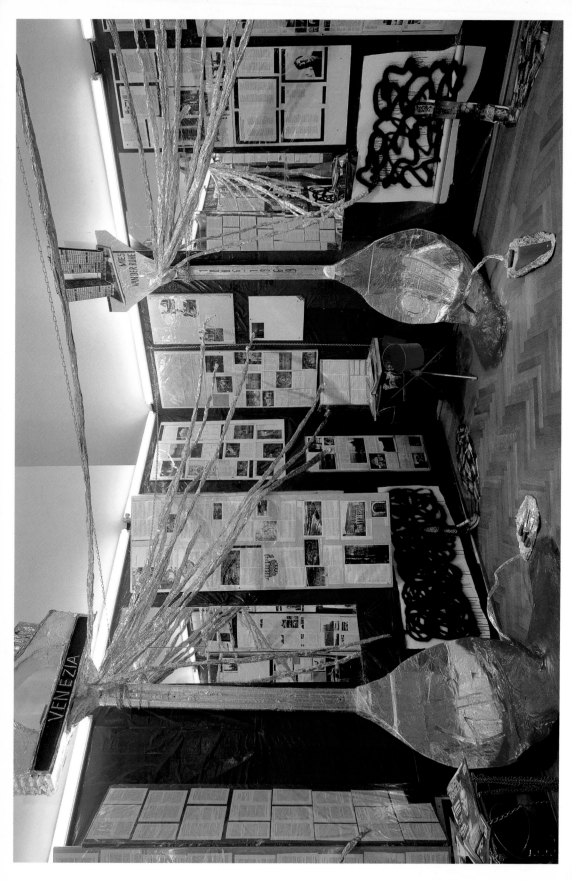

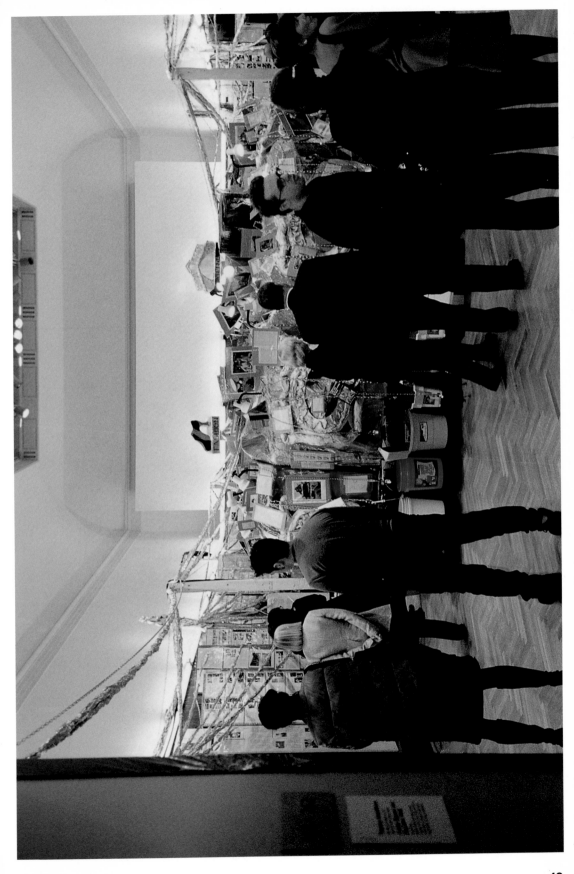

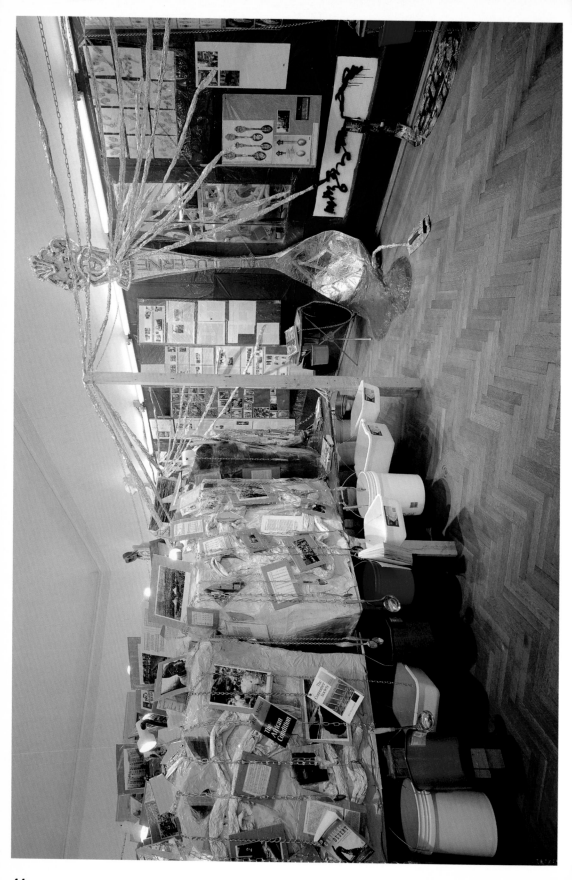

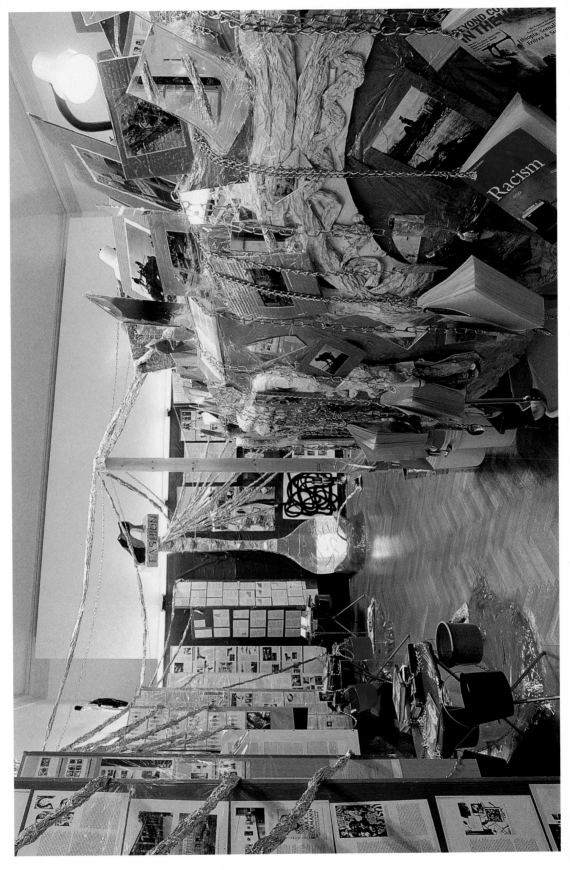

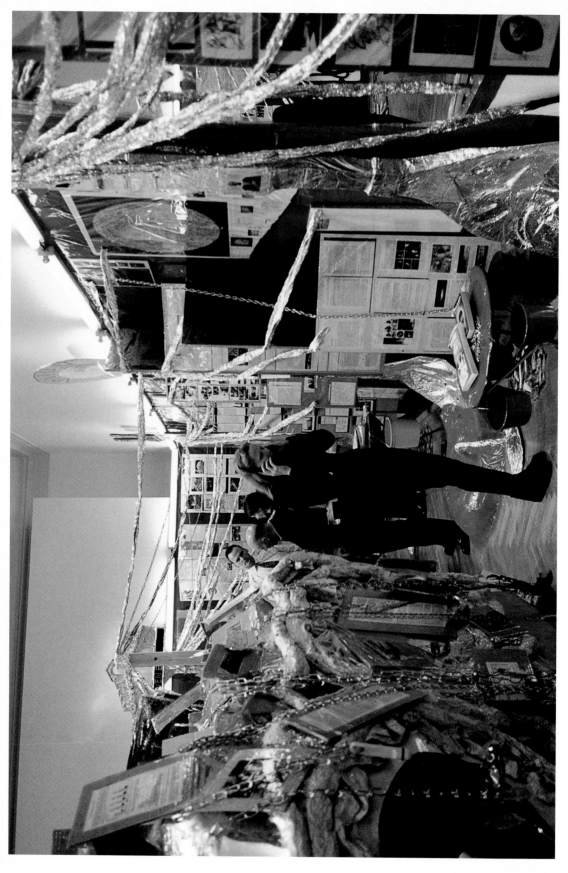

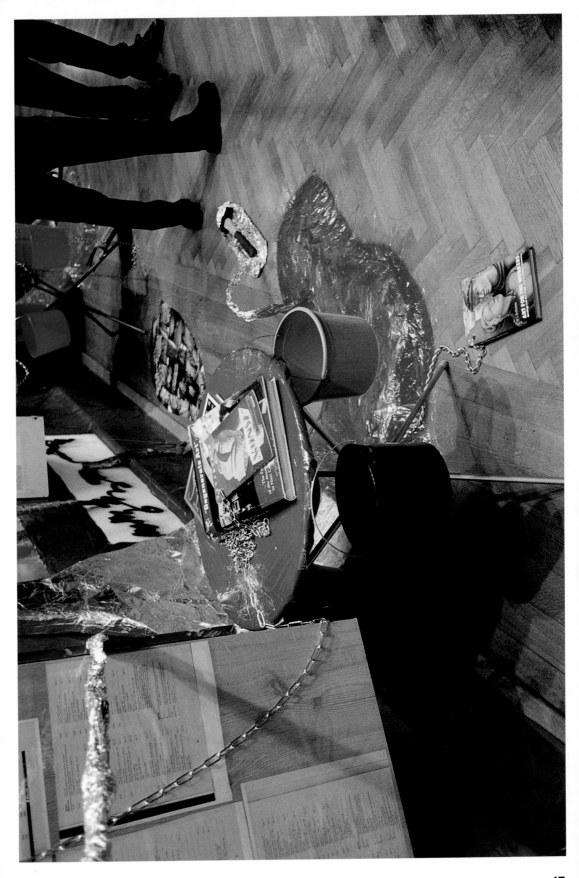

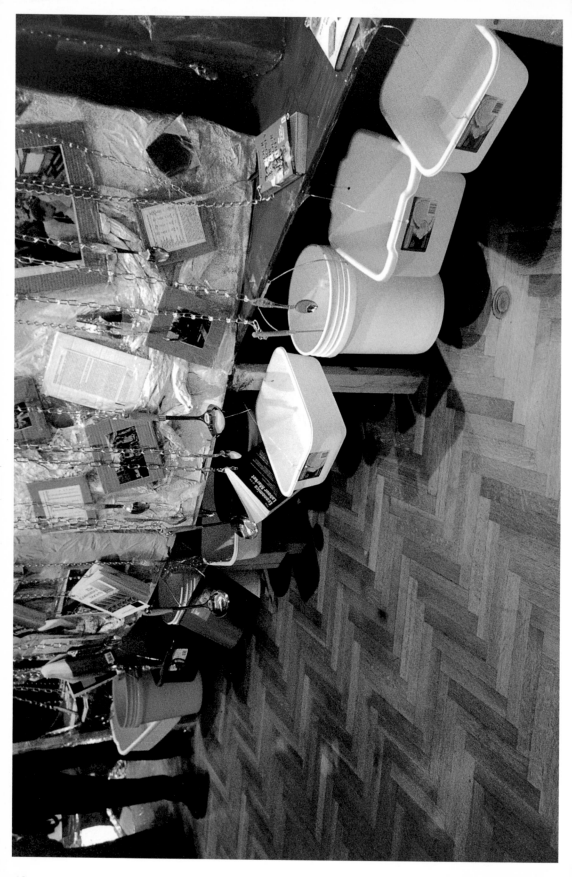

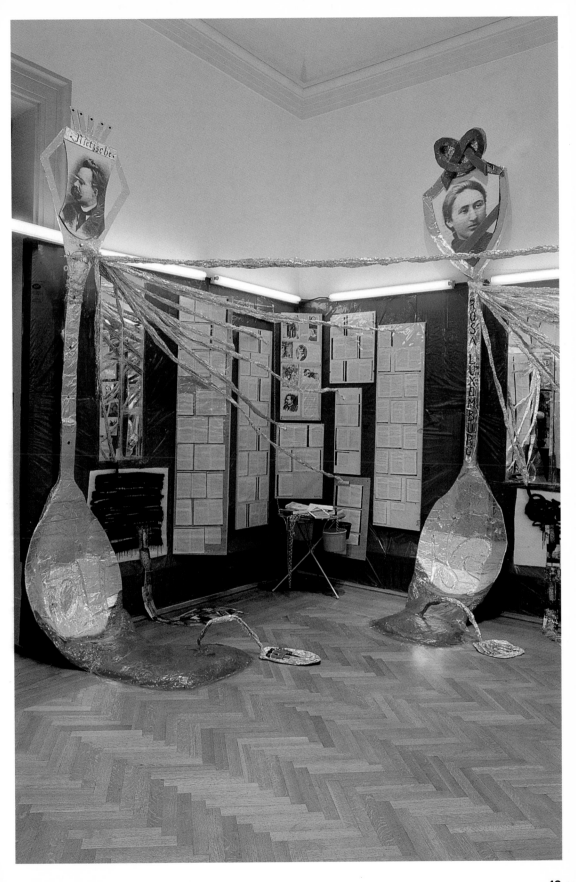

49

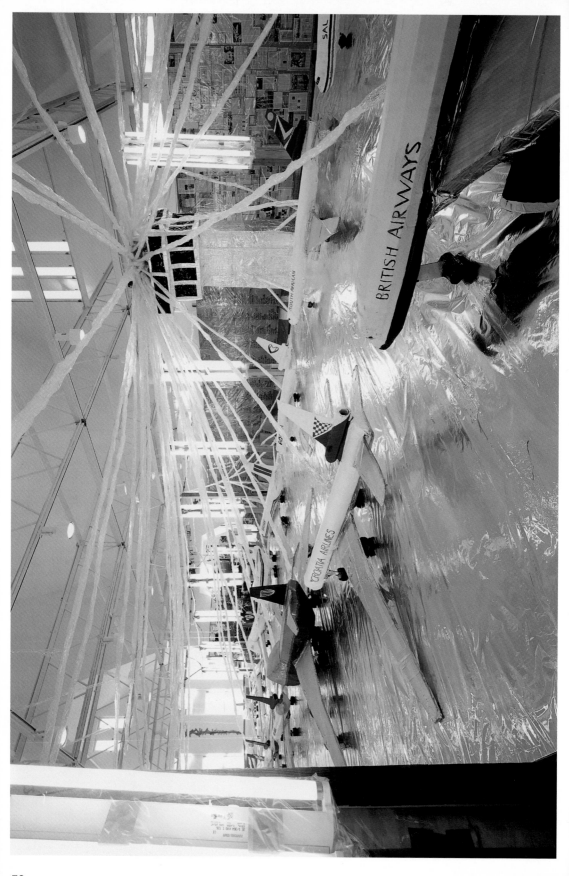

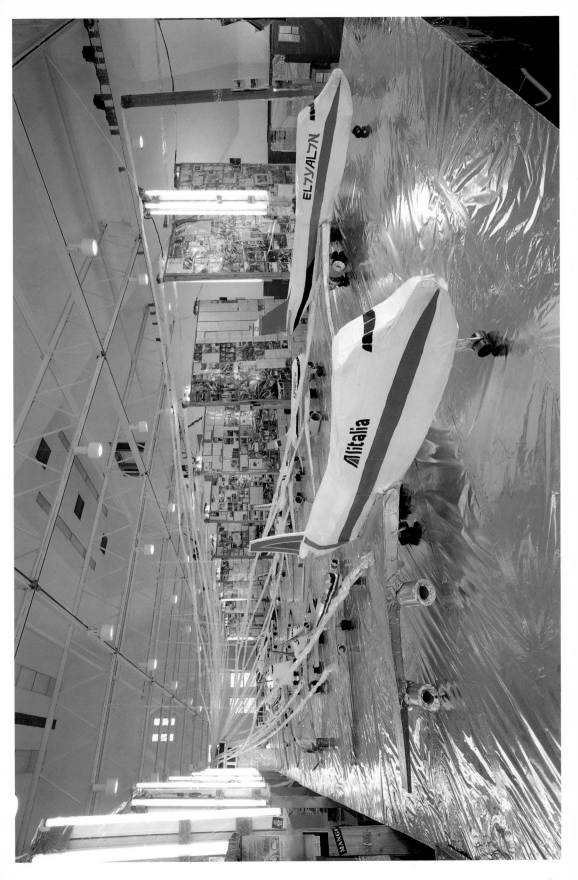

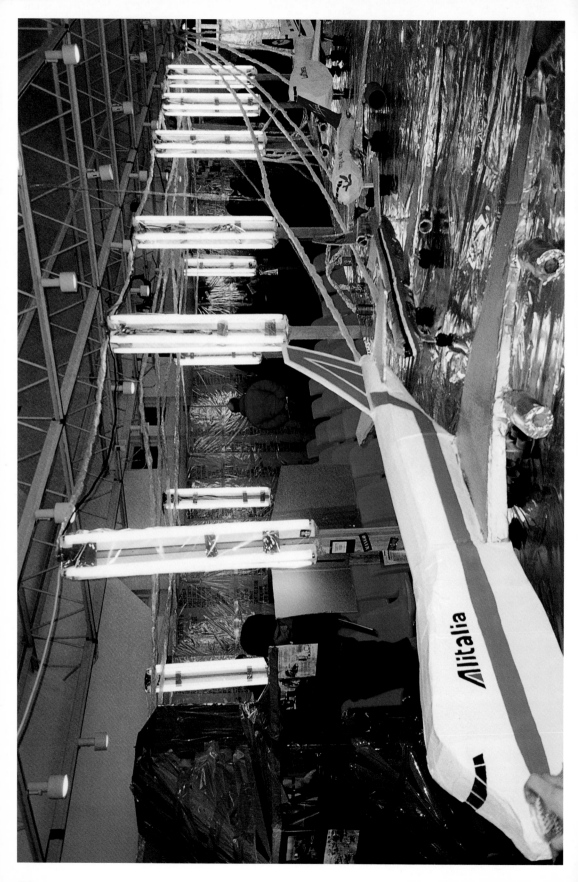

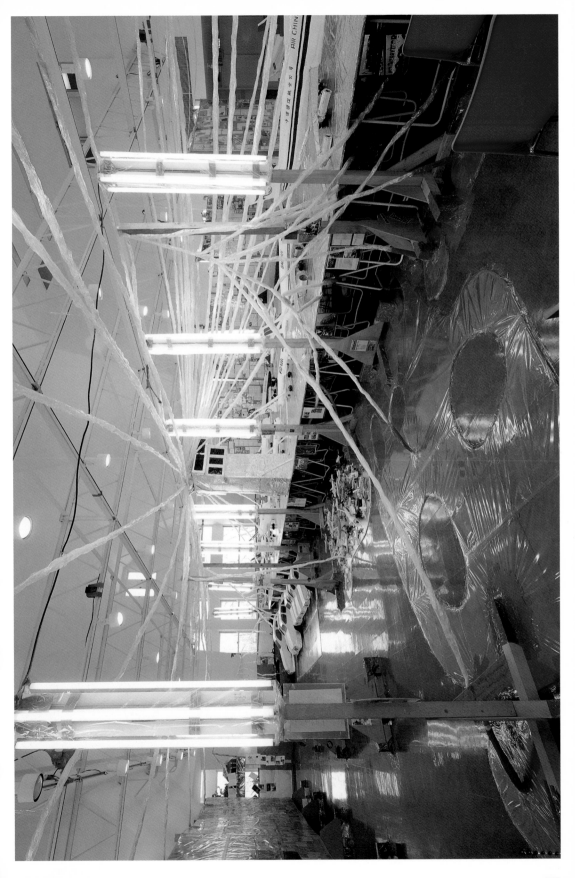

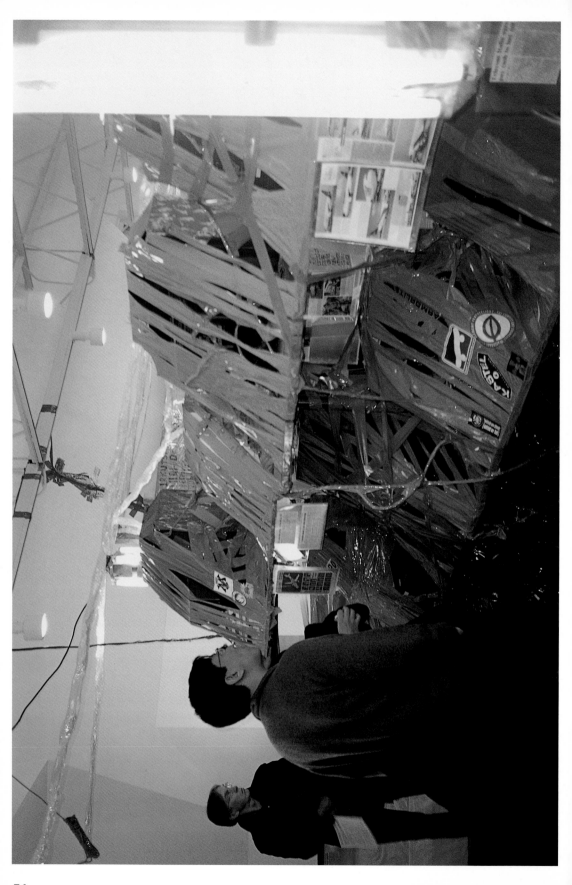

54

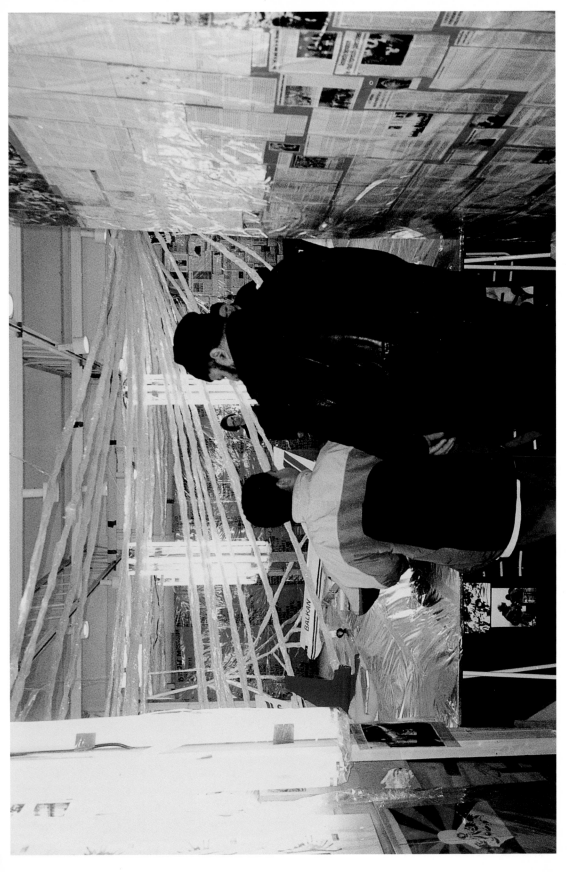

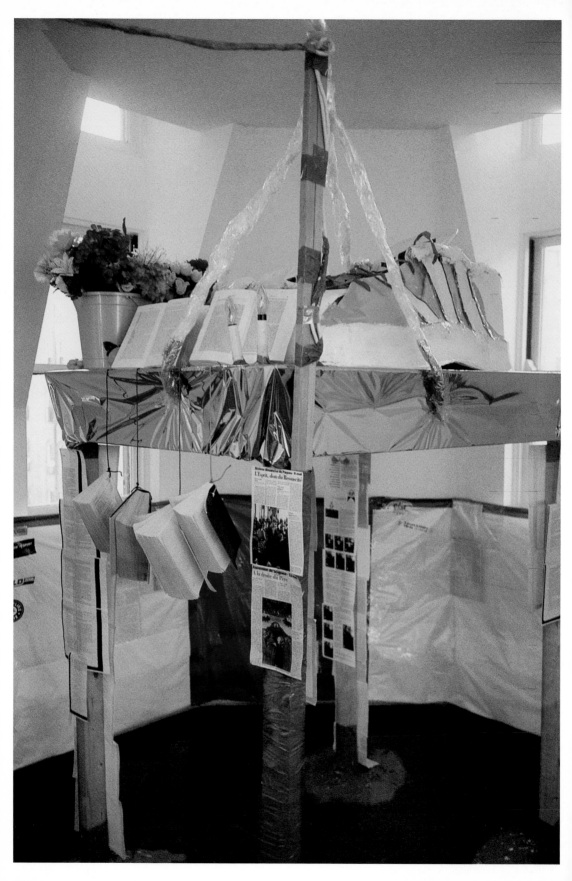

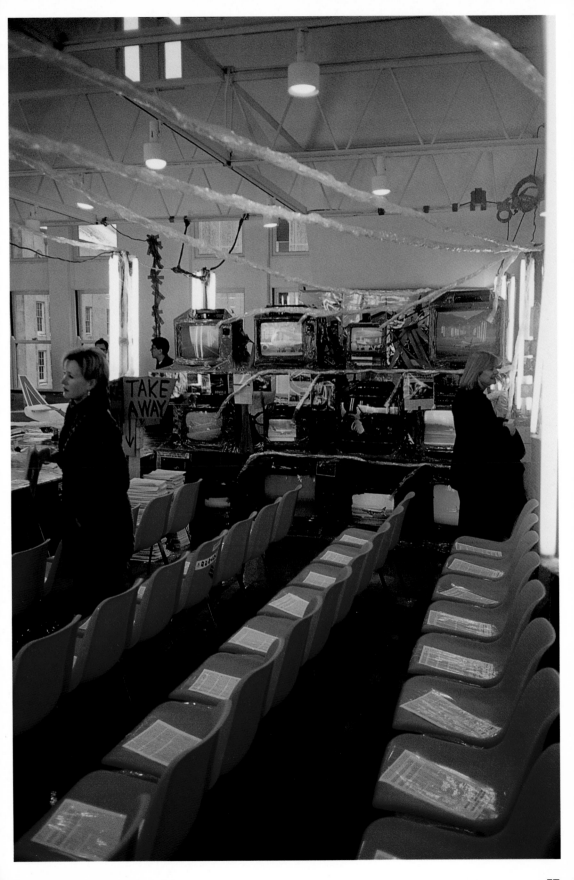

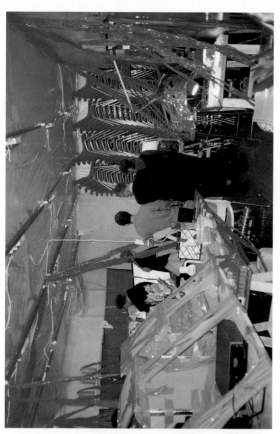

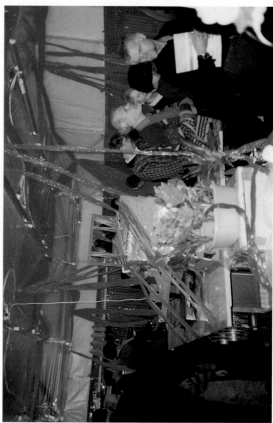

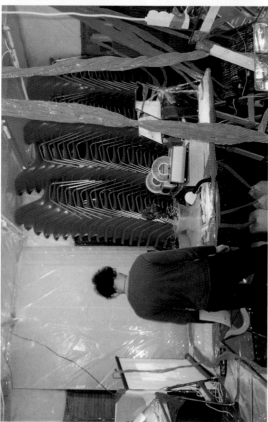

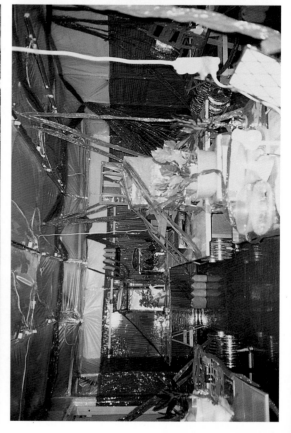

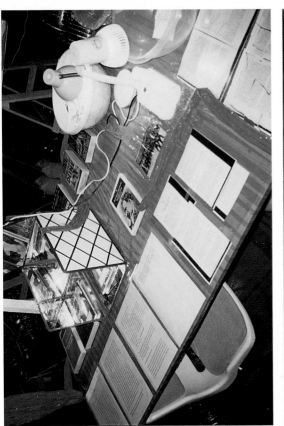

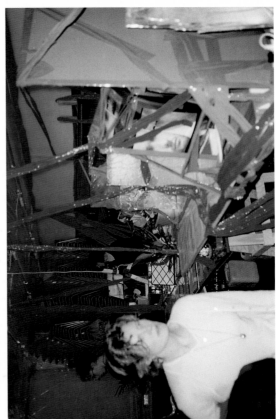

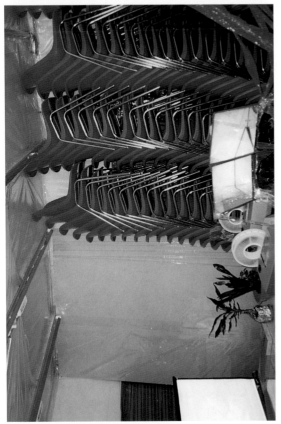

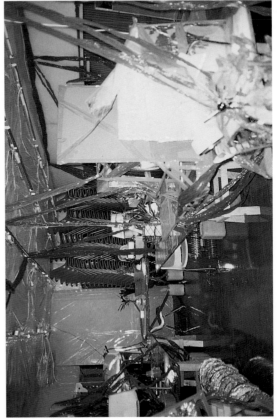

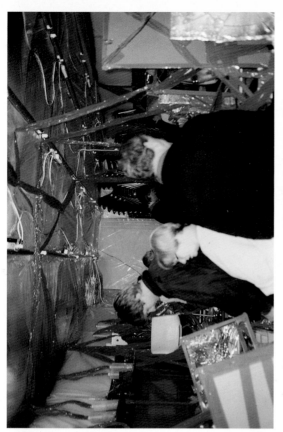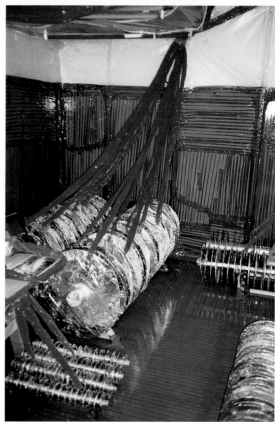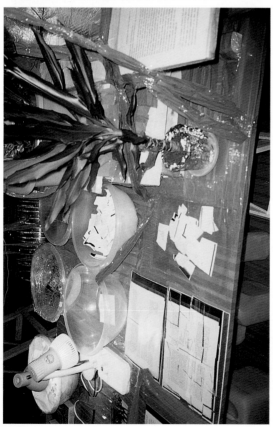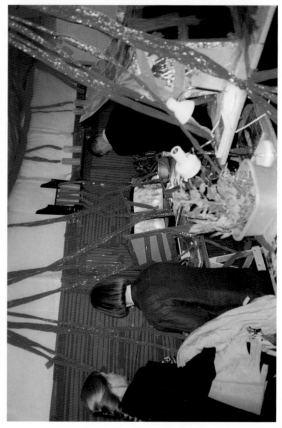

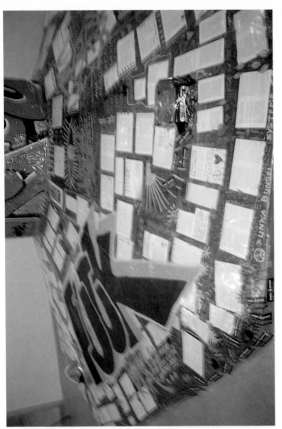

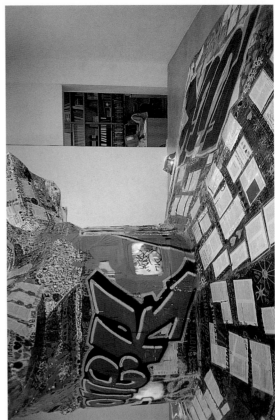

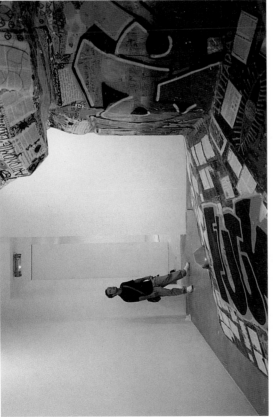

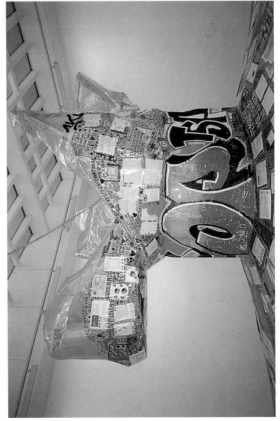

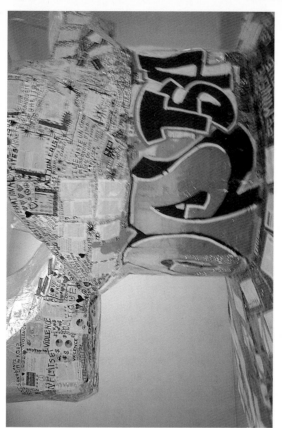

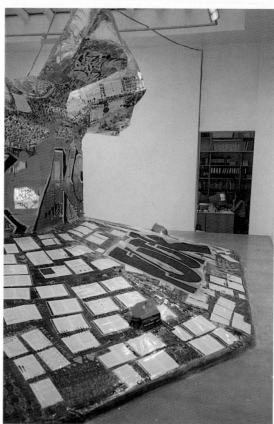

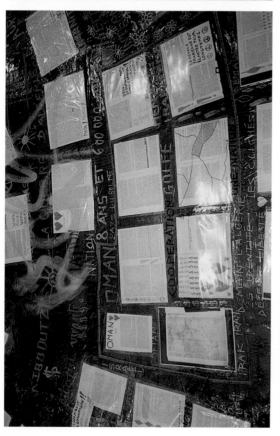

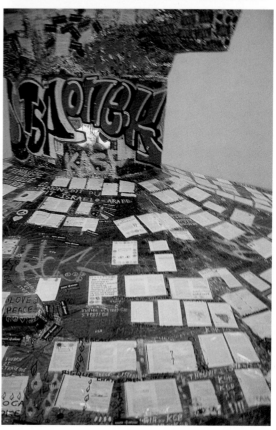

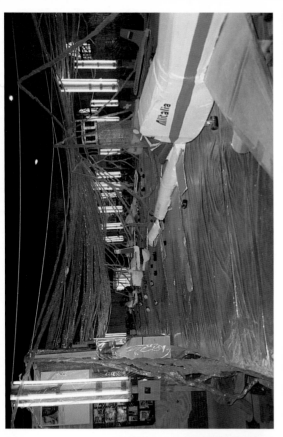

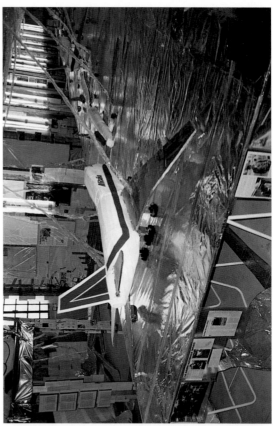

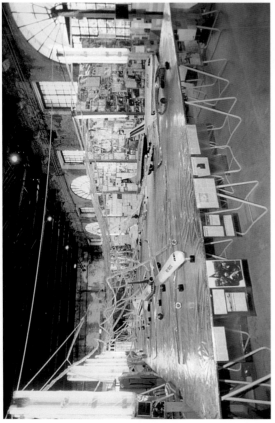

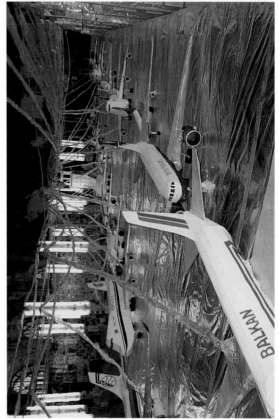

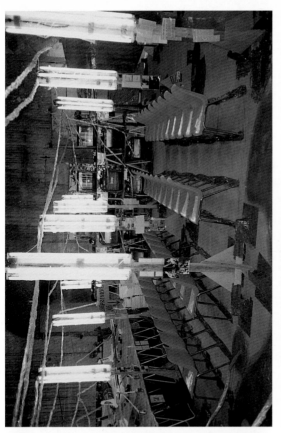

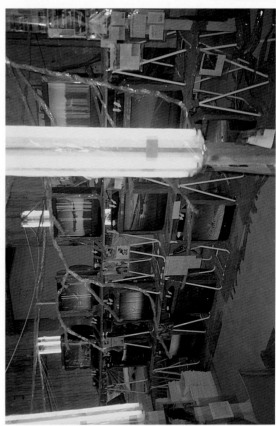

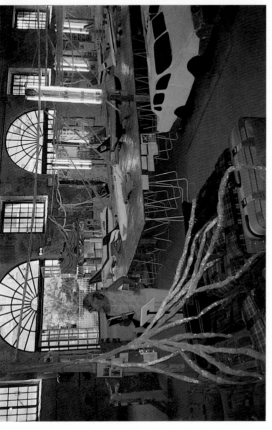

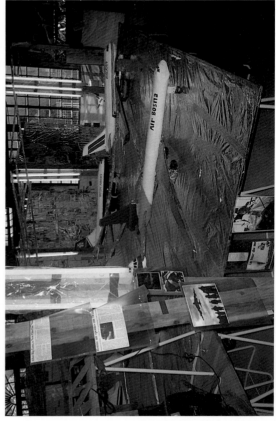

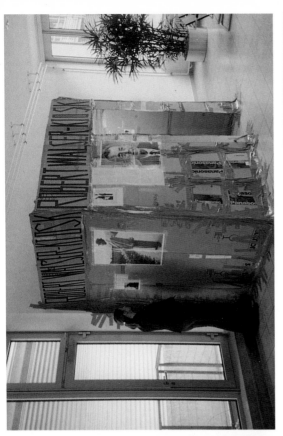

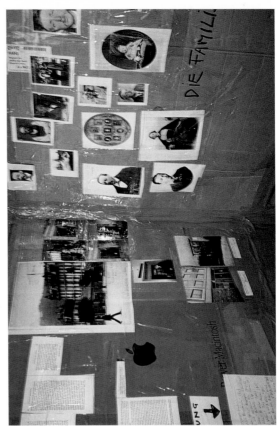

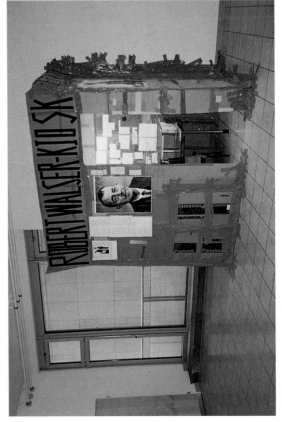

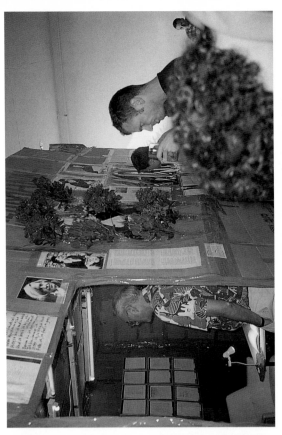

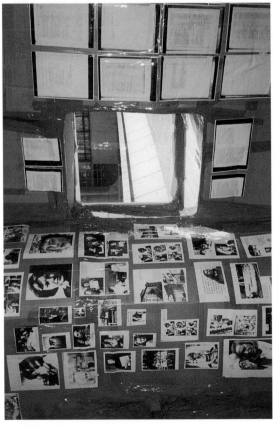

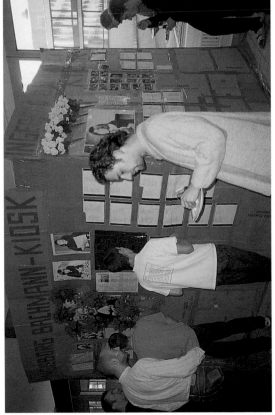

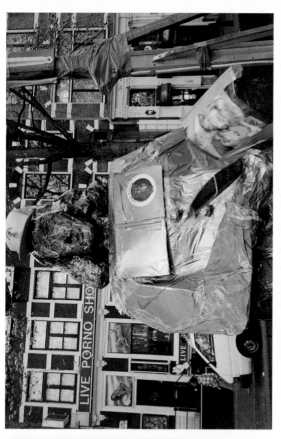
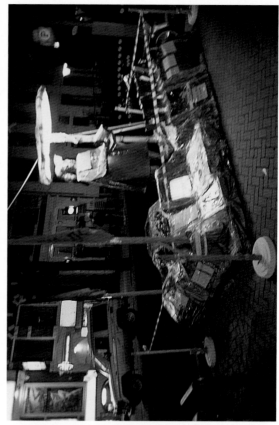
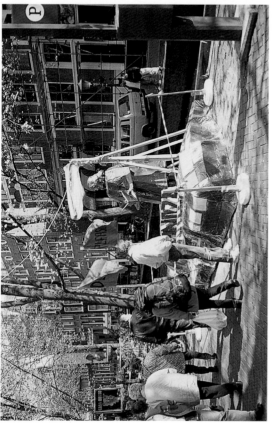
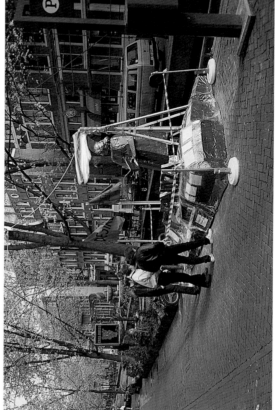

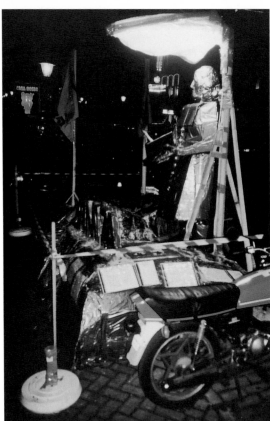

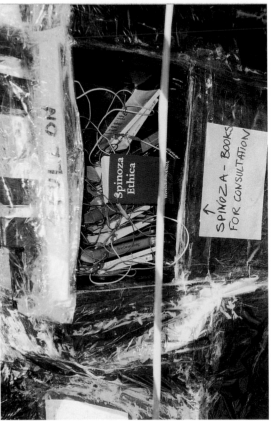

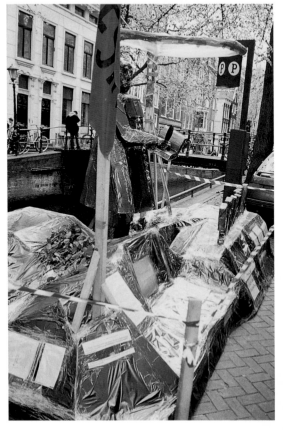

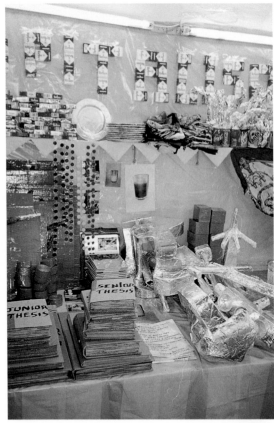

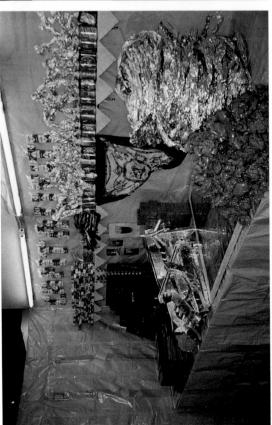

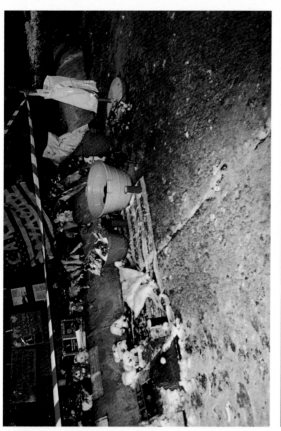

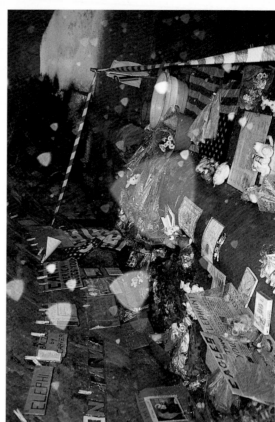

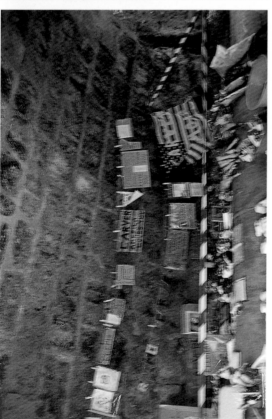

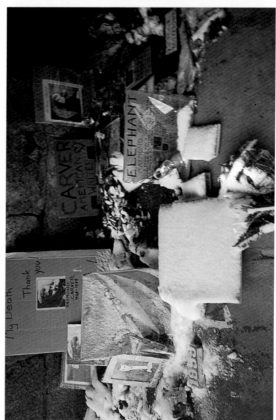

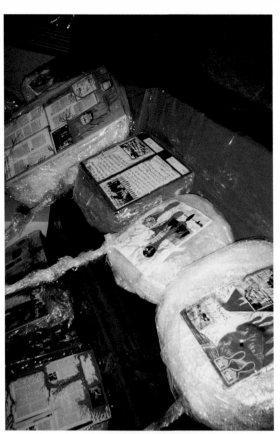

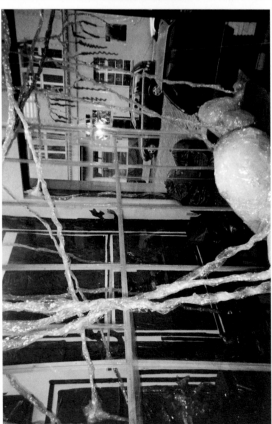

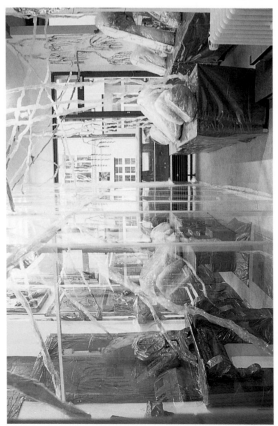

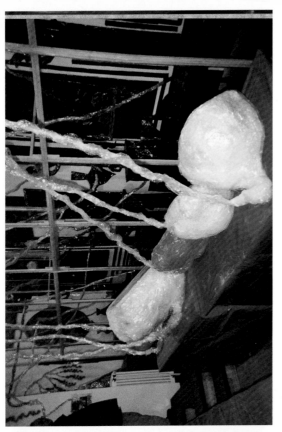

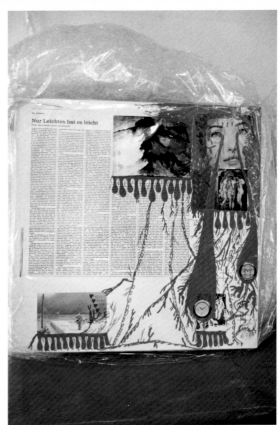

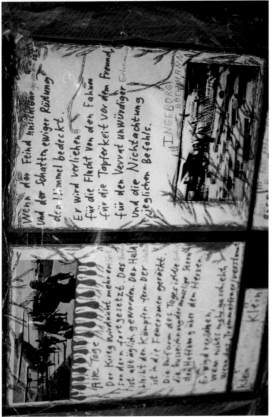

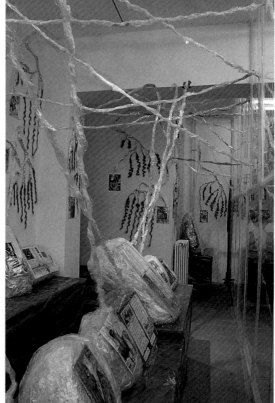

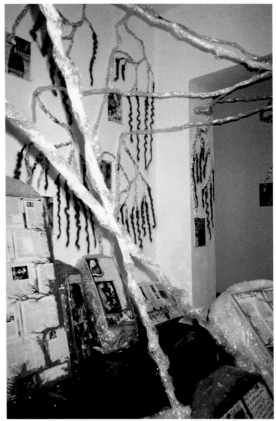

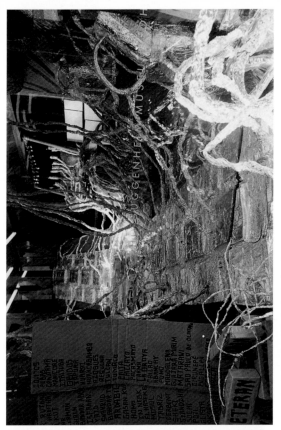

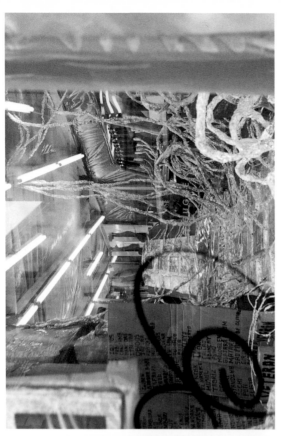
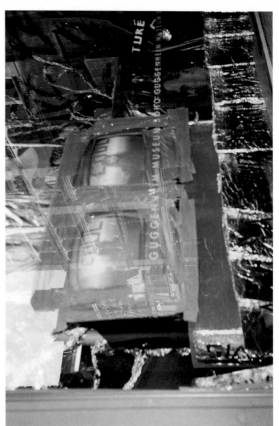
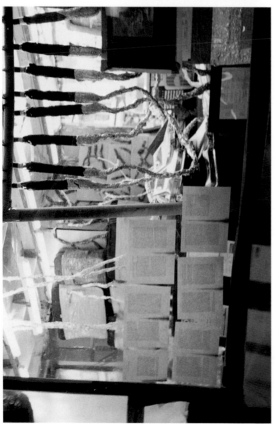
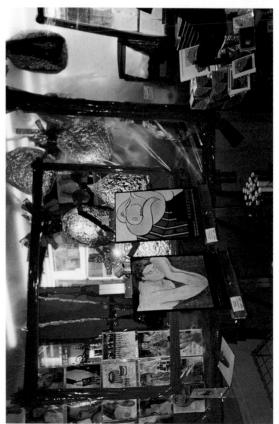

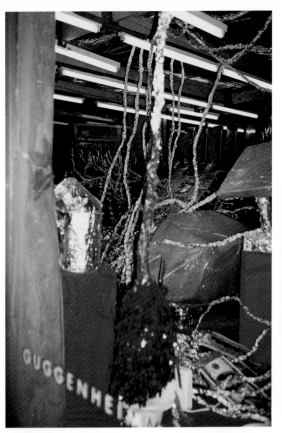

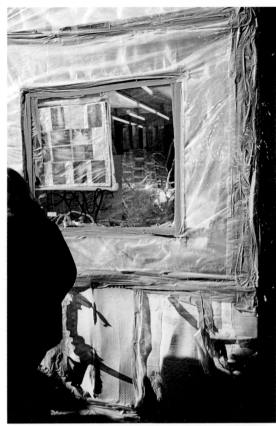

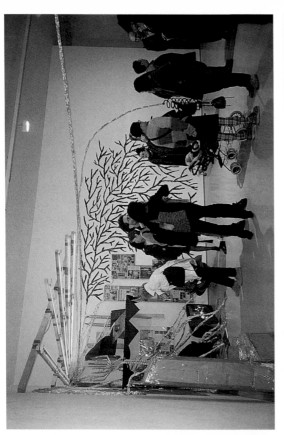
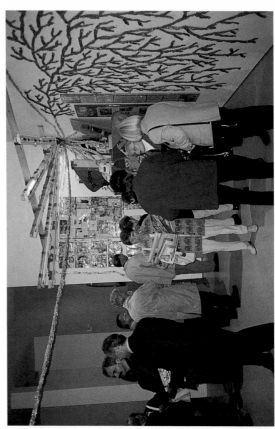
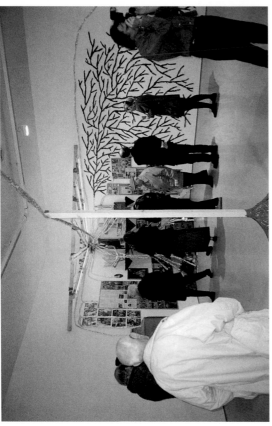
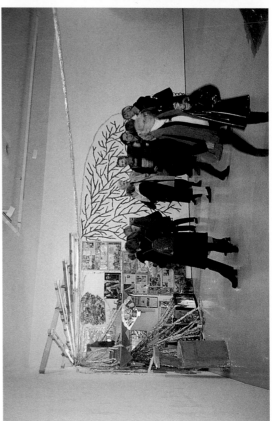

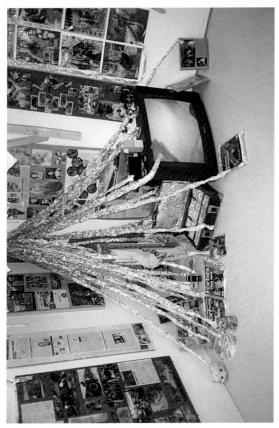

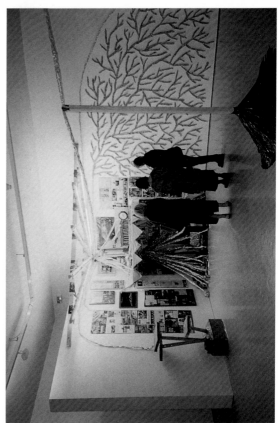

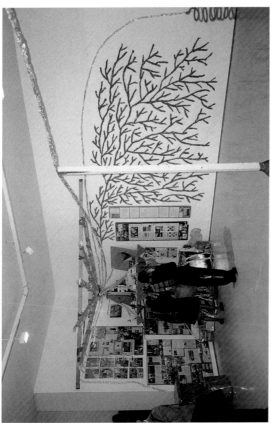

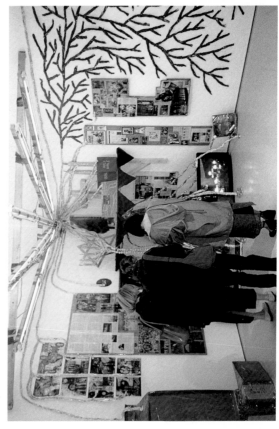

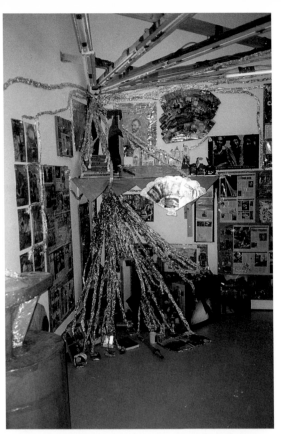

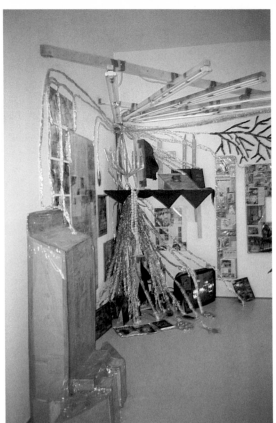

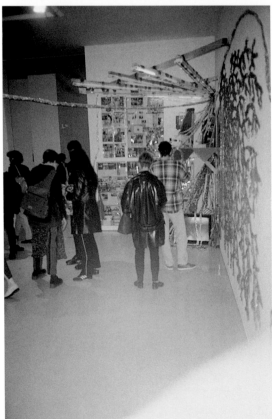

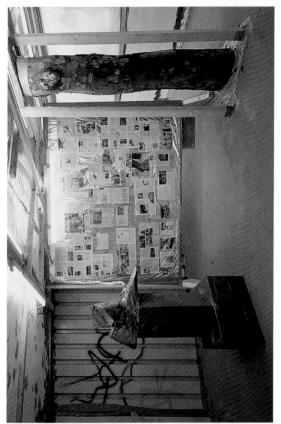

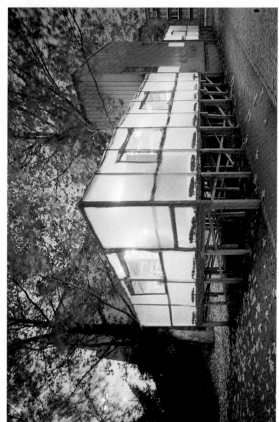

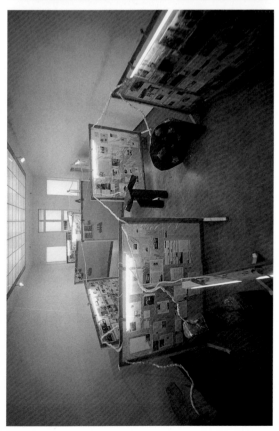

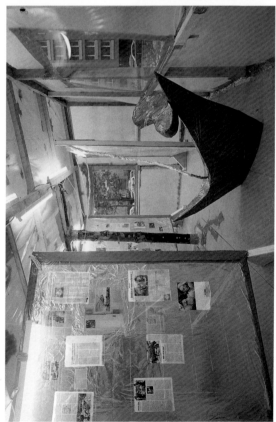

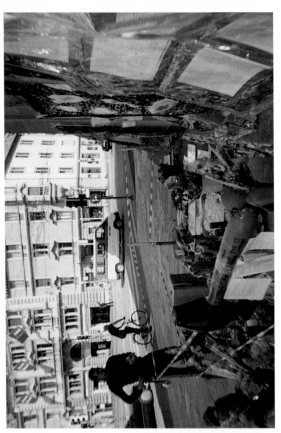

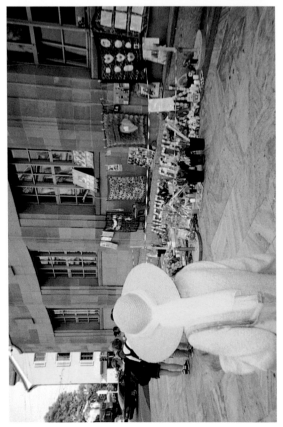

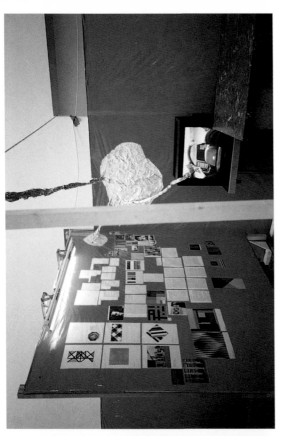

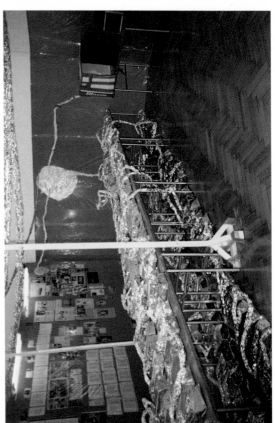

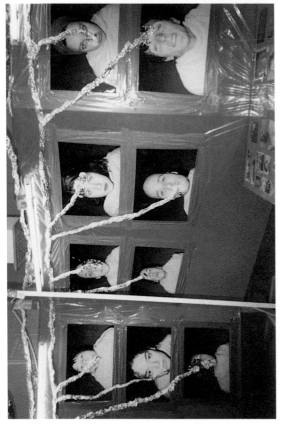

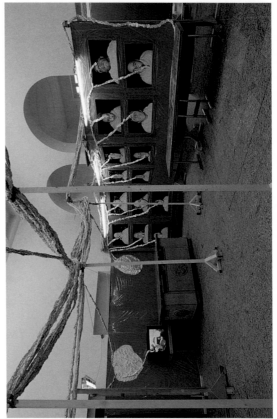

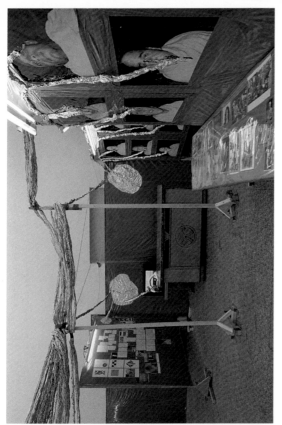

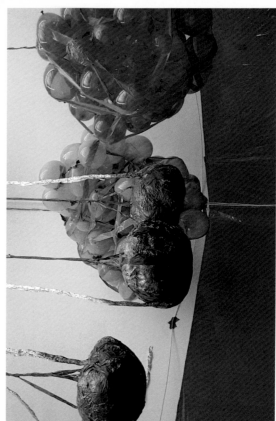

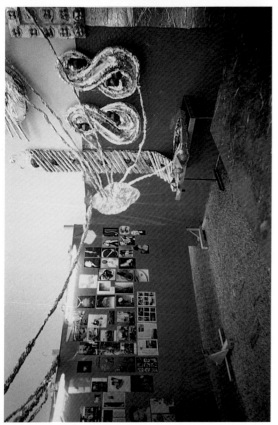

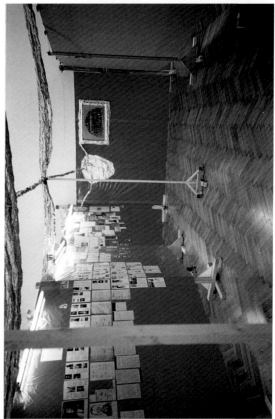

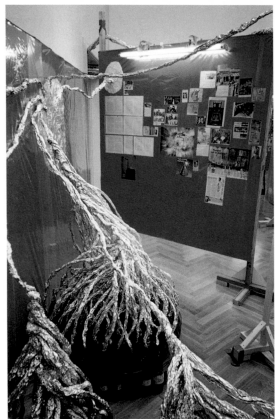

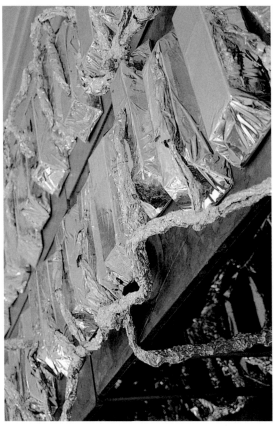

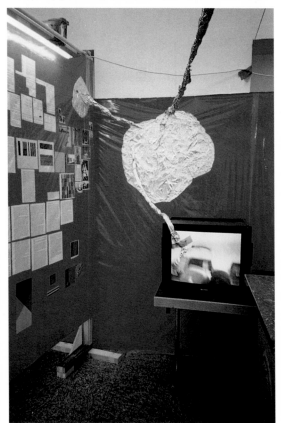

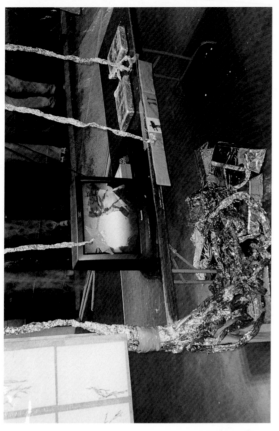

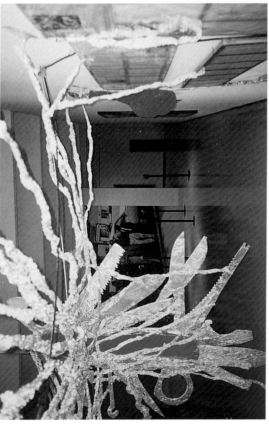

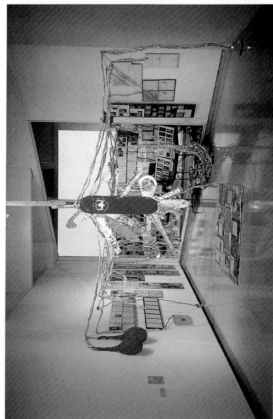

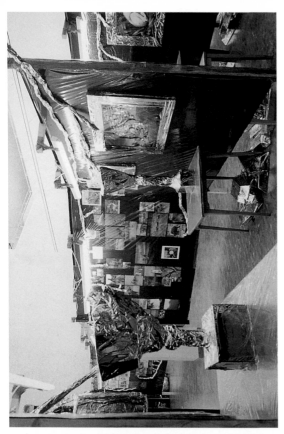

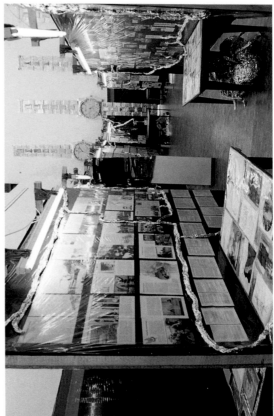

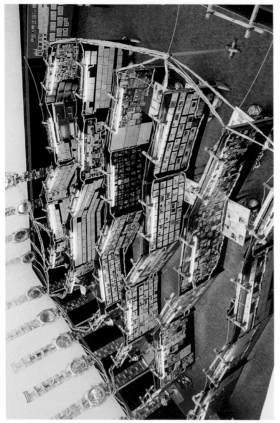

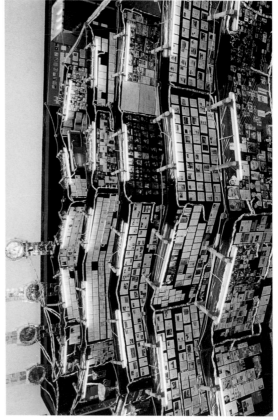

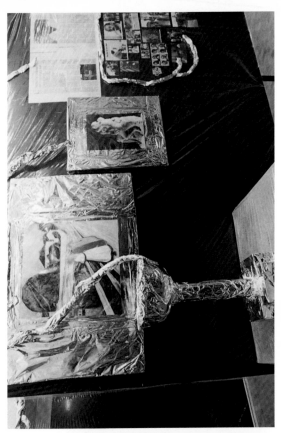

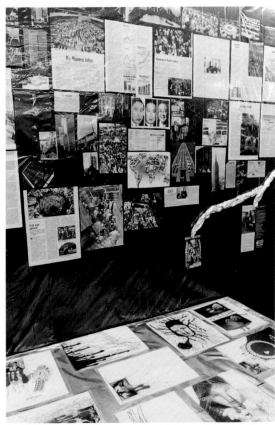

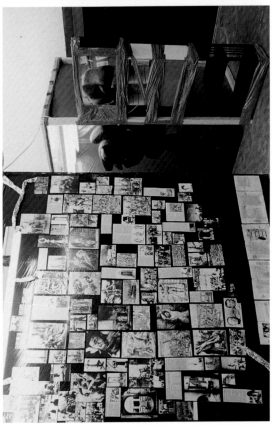

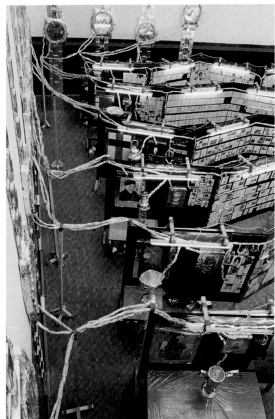

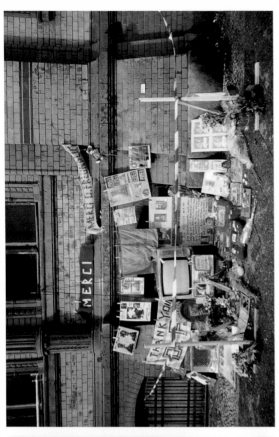

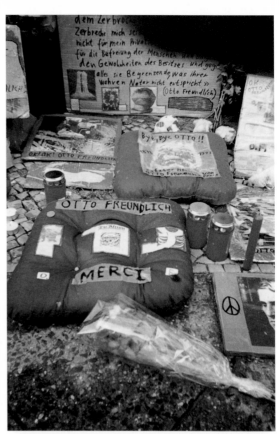

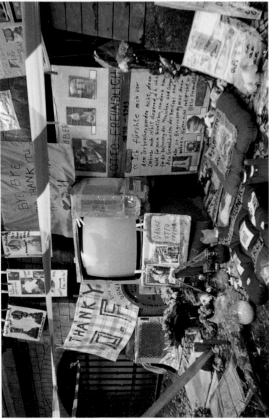

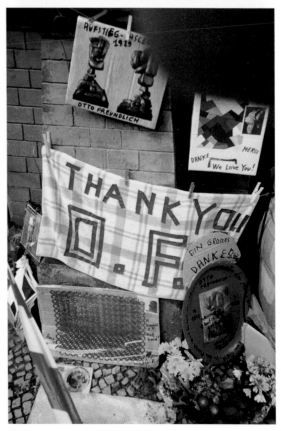

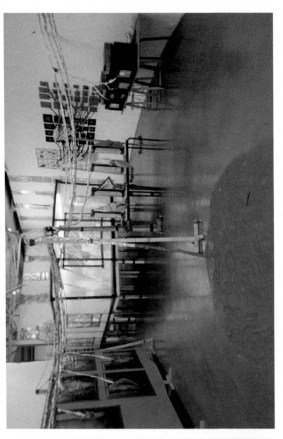

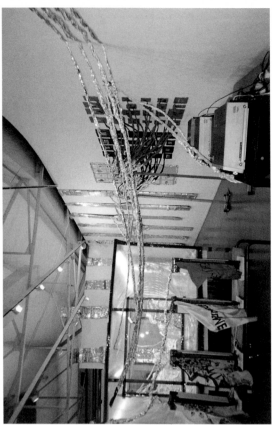

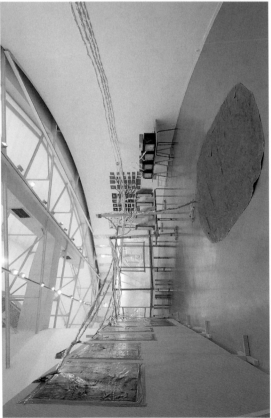

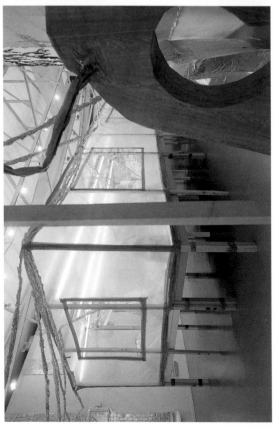

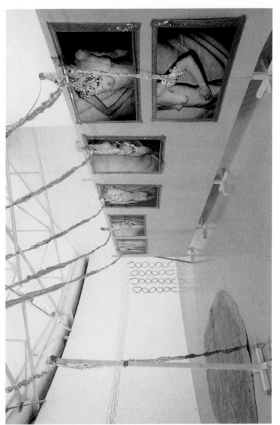

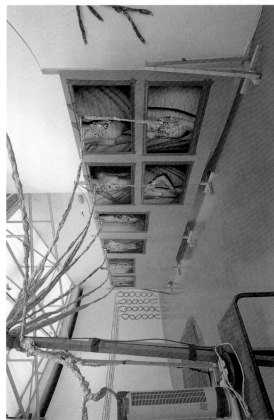

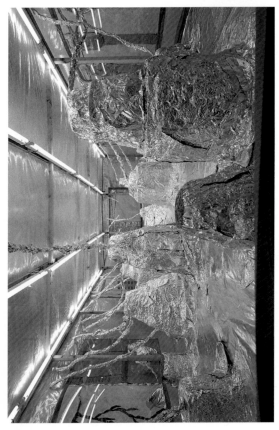

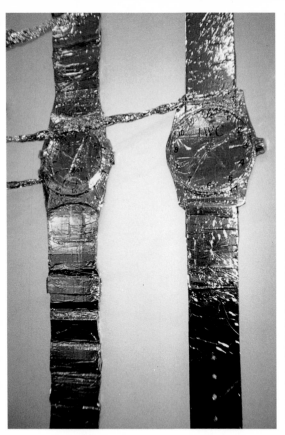

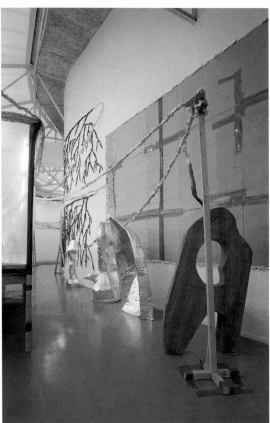

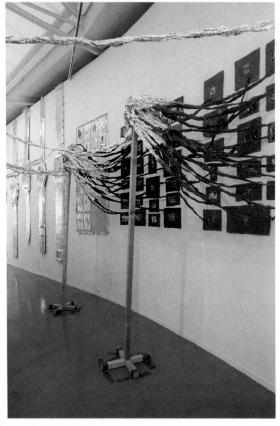

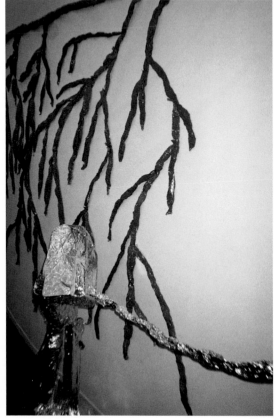

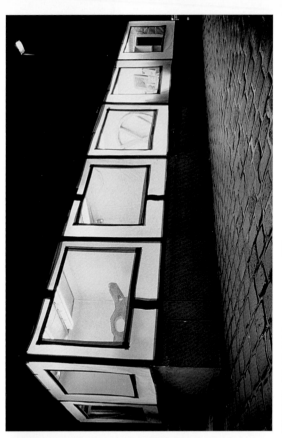

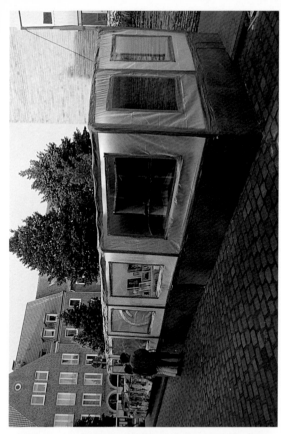

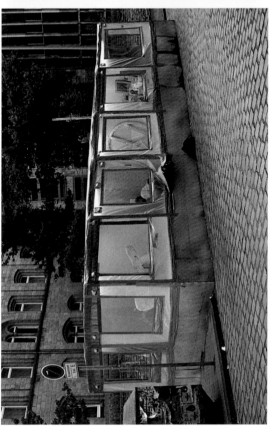

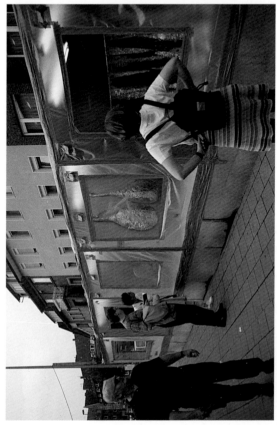

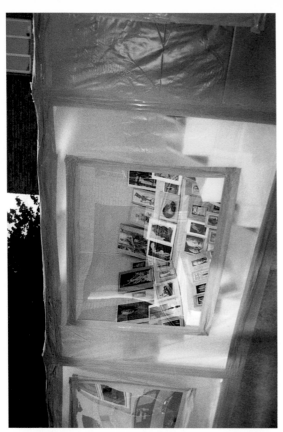
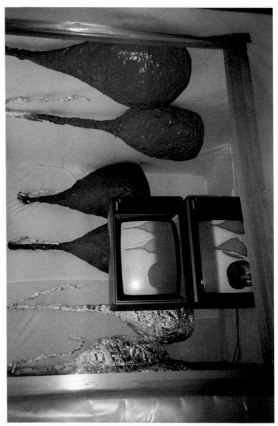

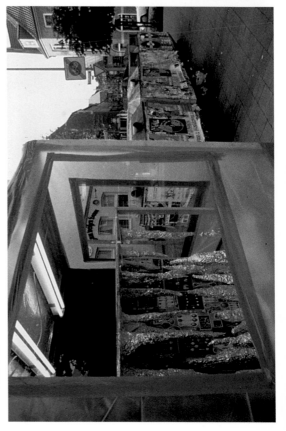

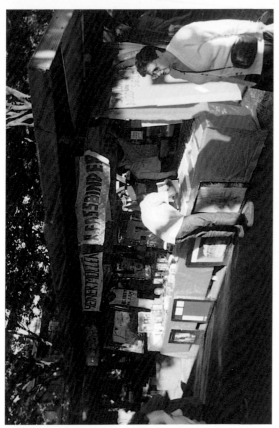

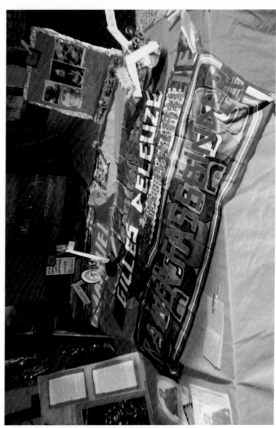

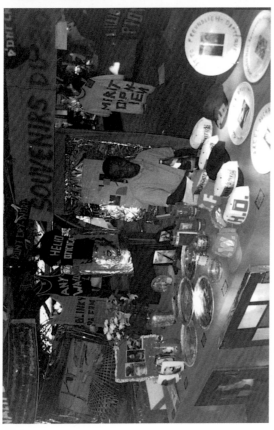

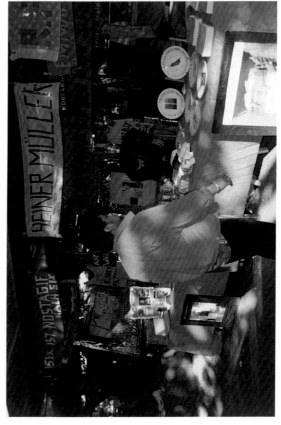

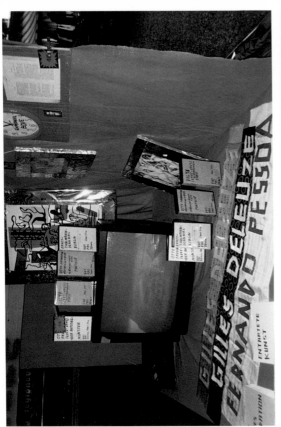

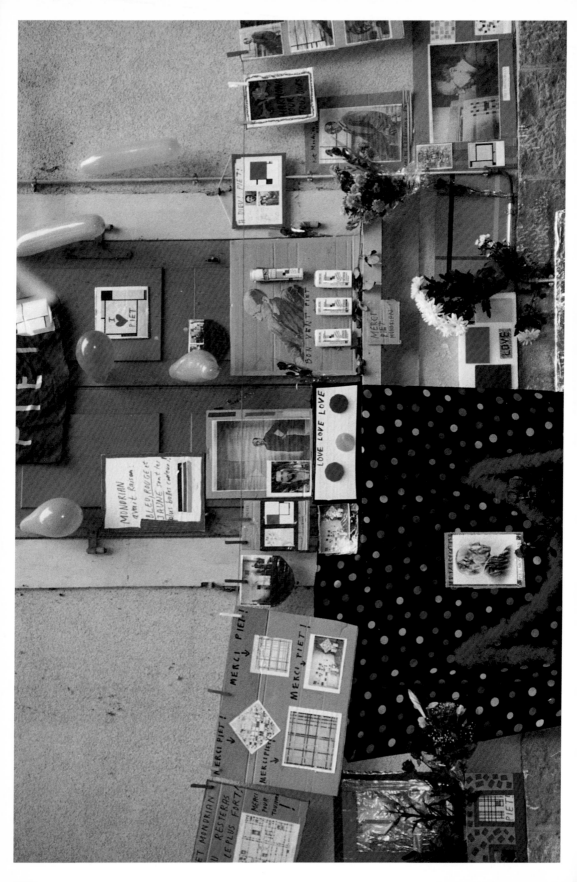

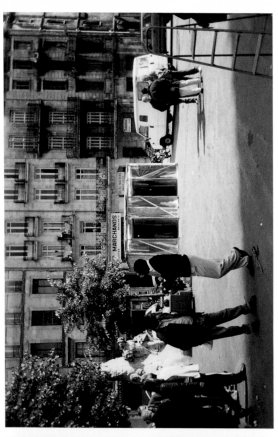

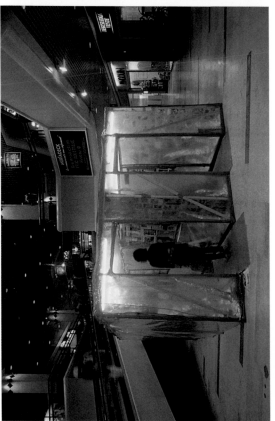

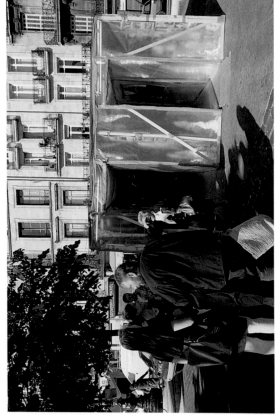

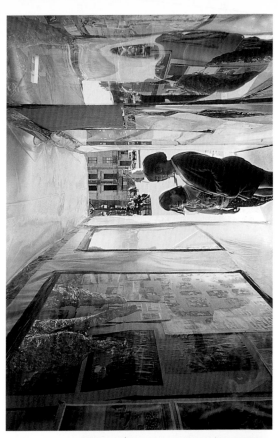

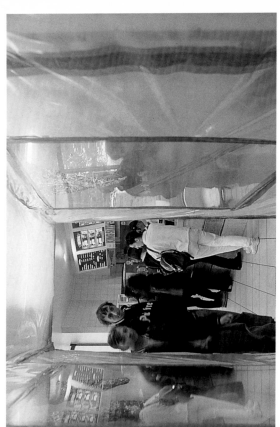

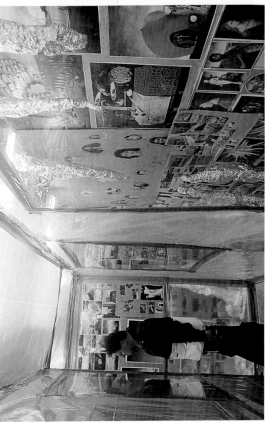

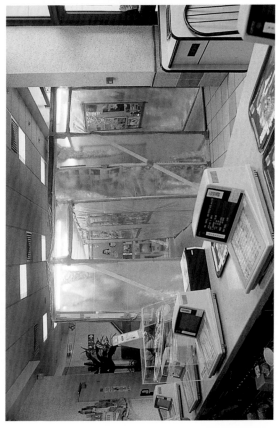

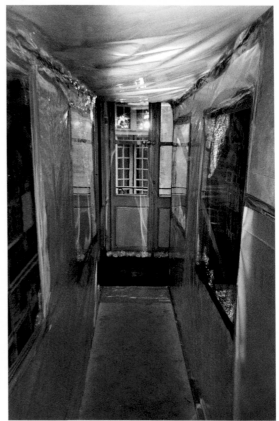
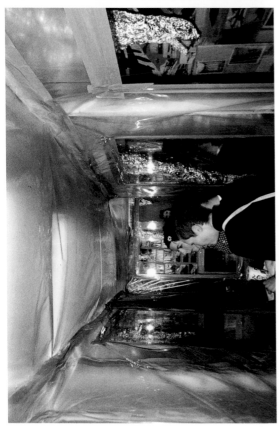
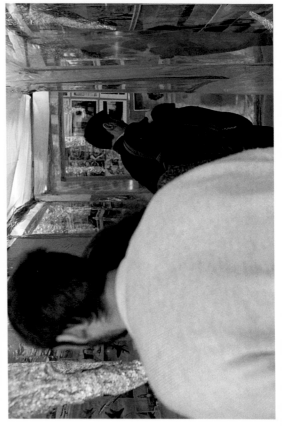

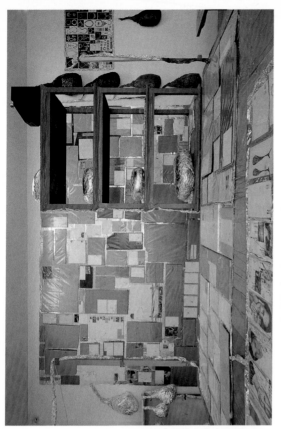

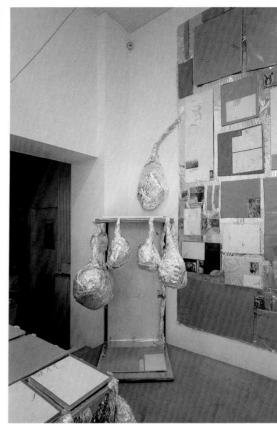

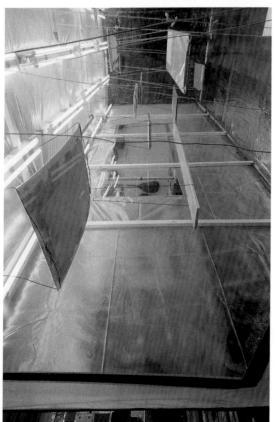

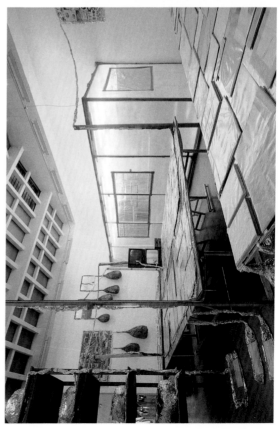

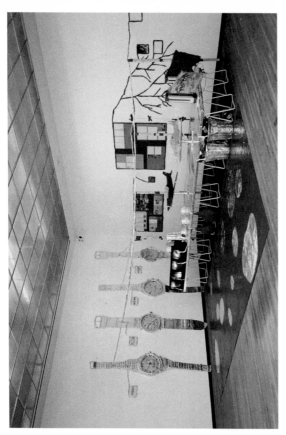

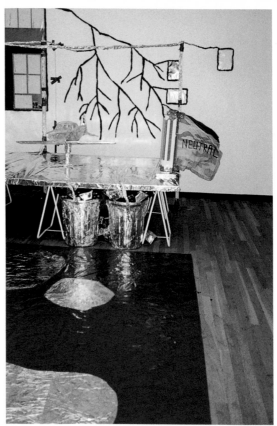

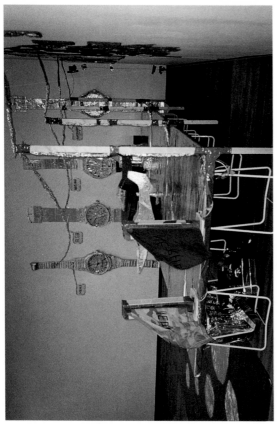

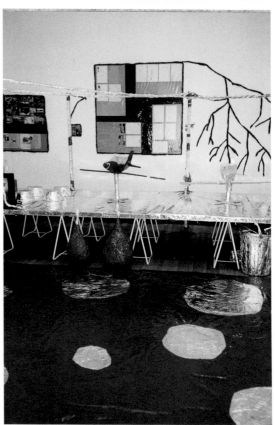

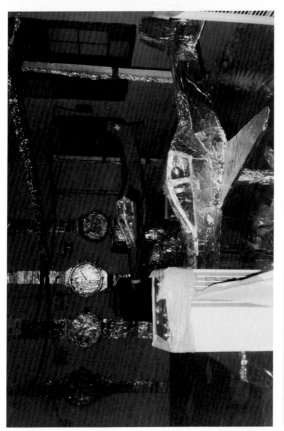
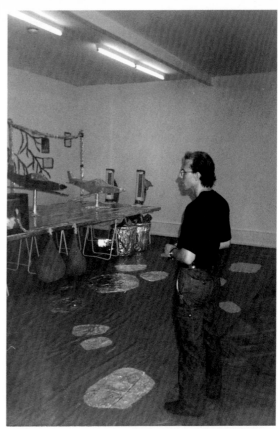
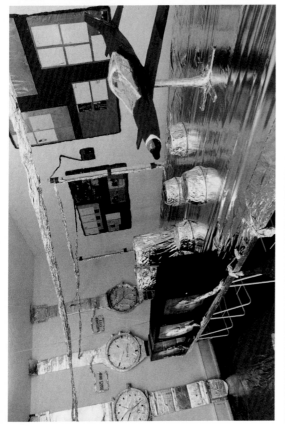
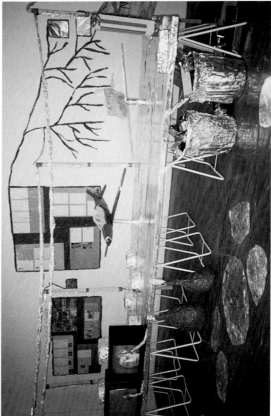

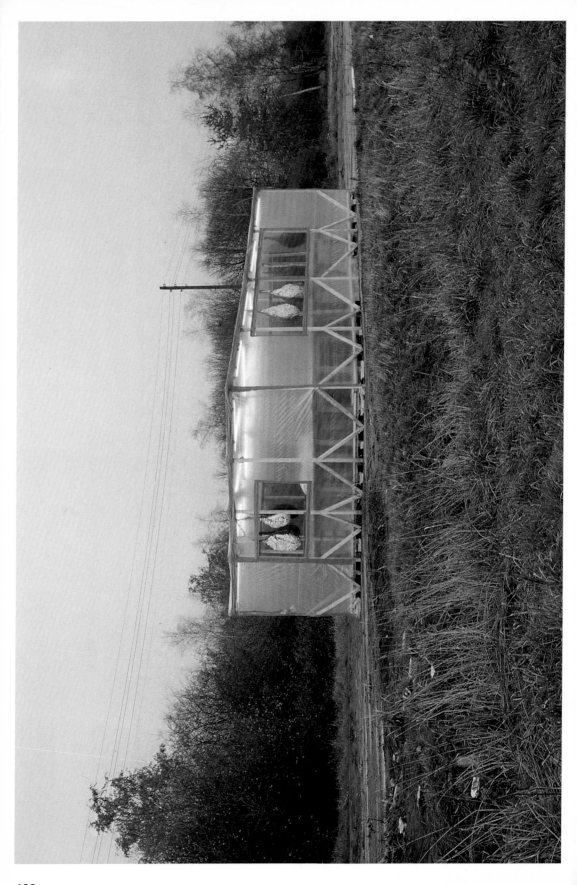

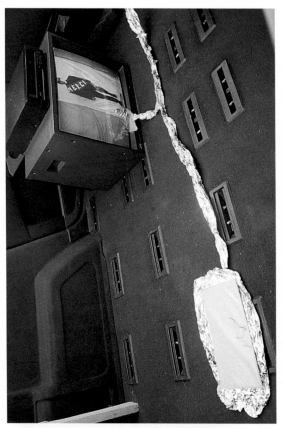
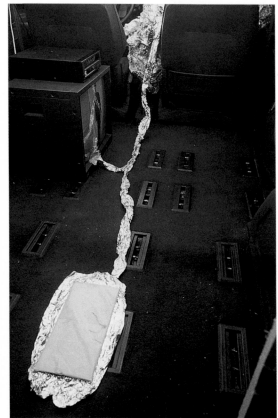
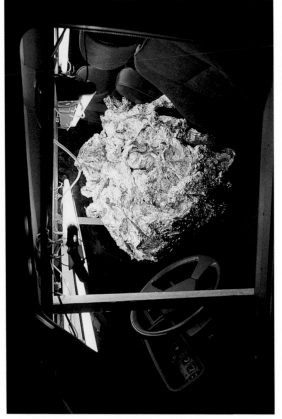
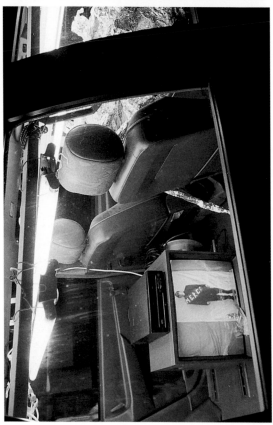

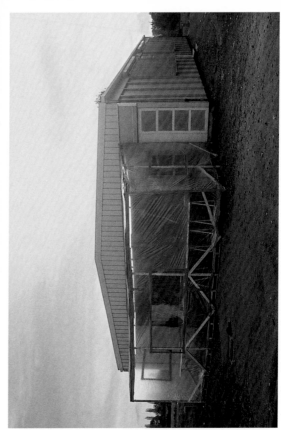

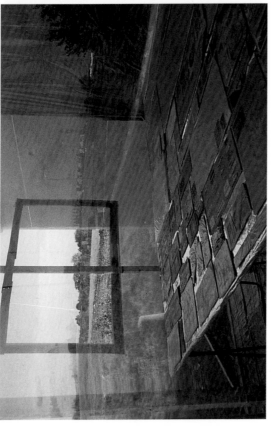

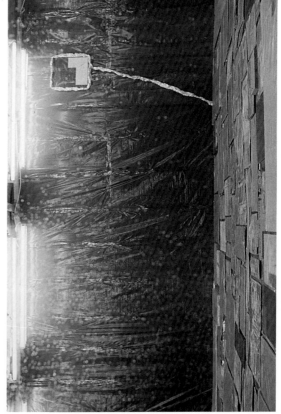

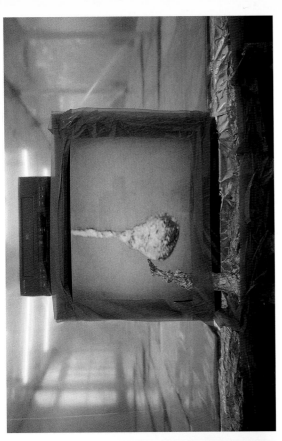

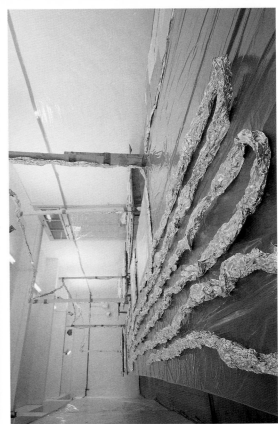

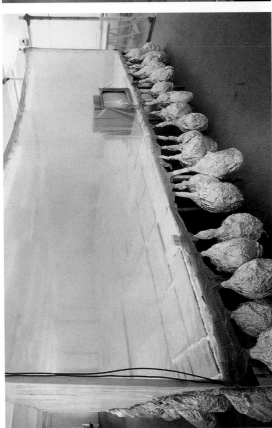

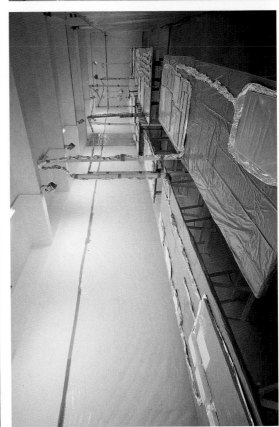

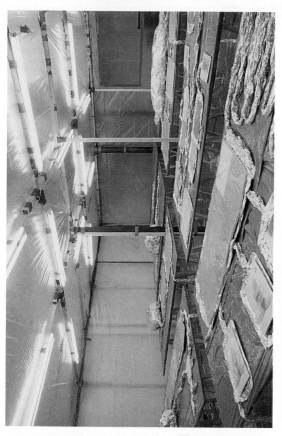

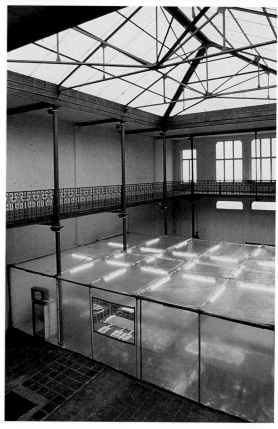

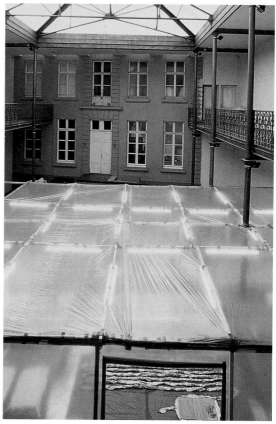

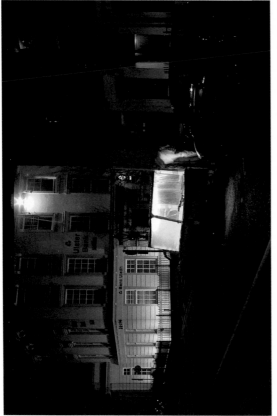

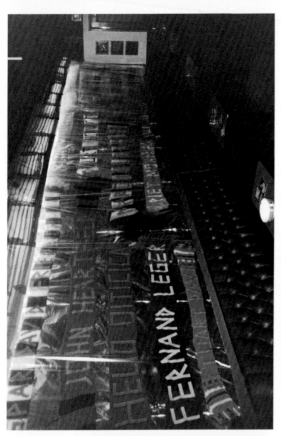

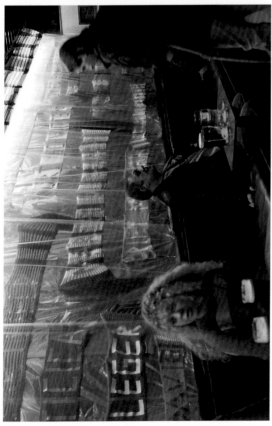

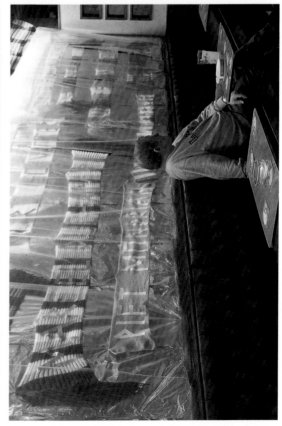

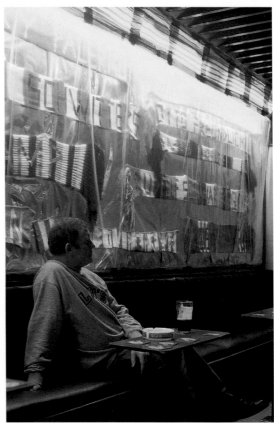

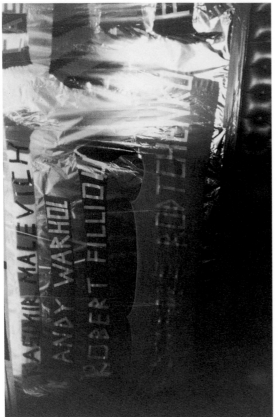

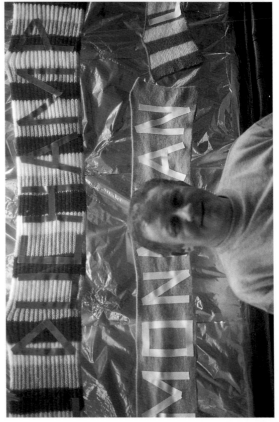

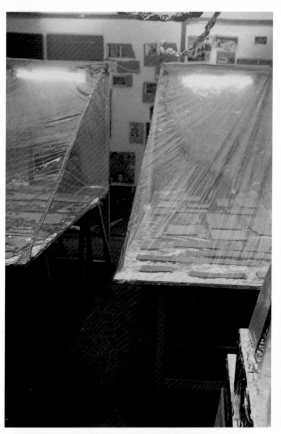
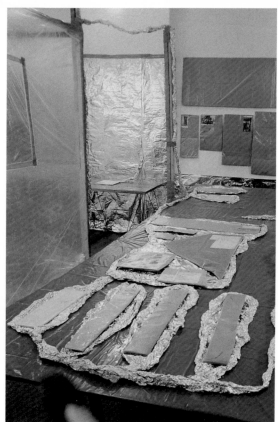
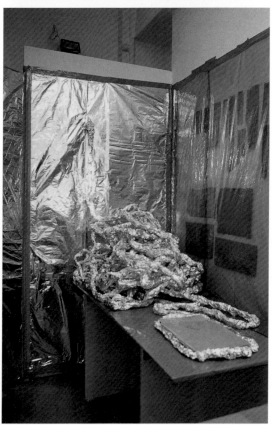
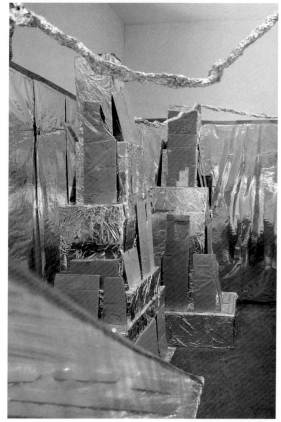

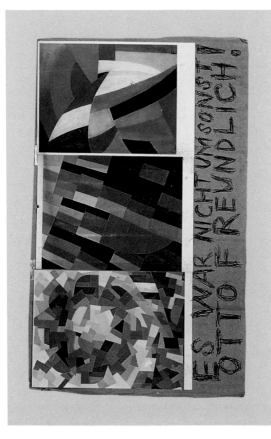

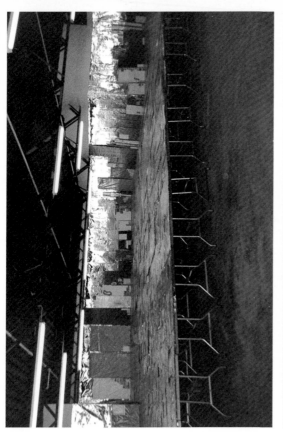

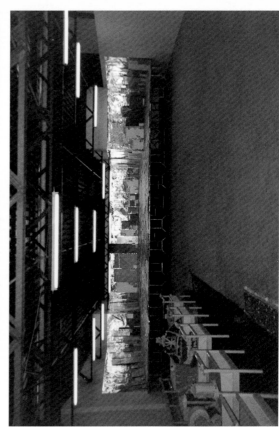

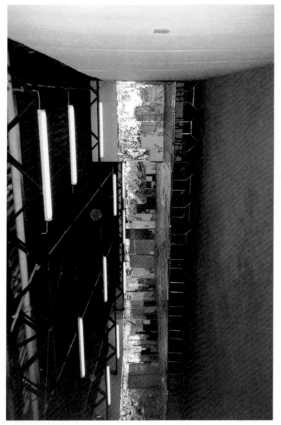

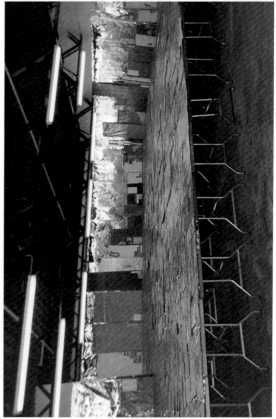

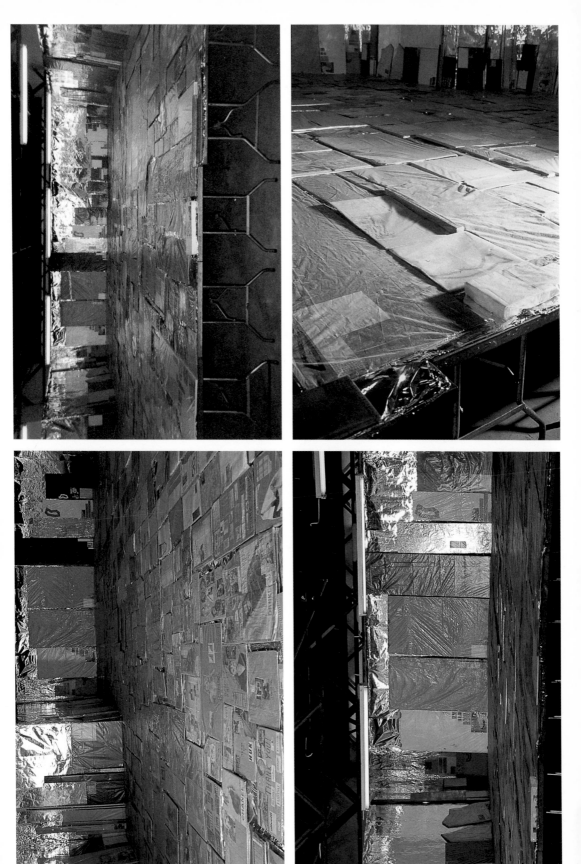

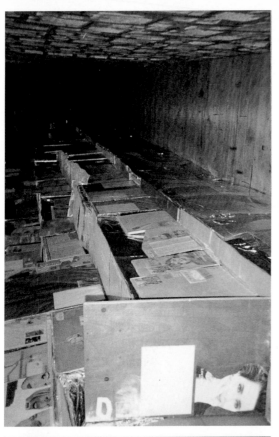

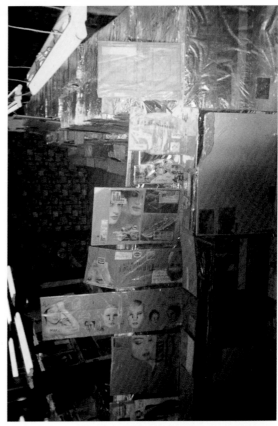

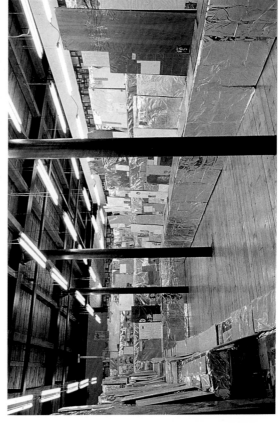

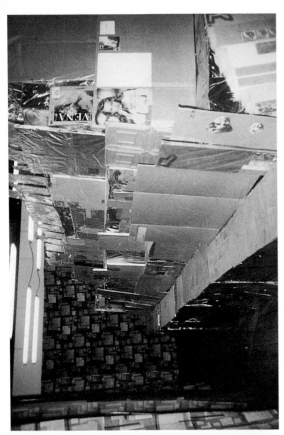
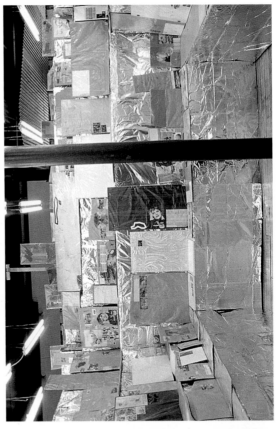
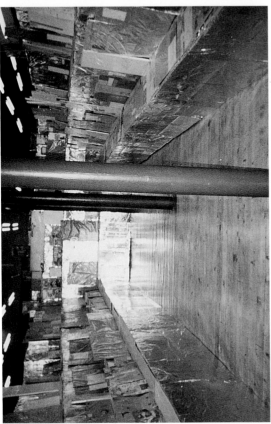
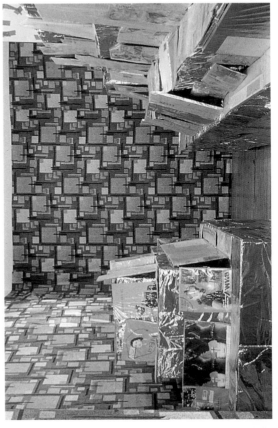

124

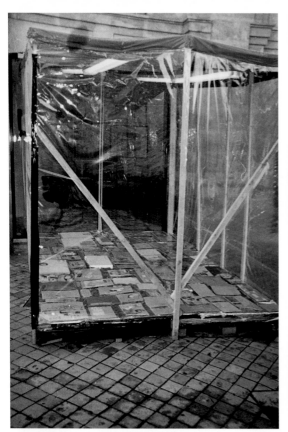
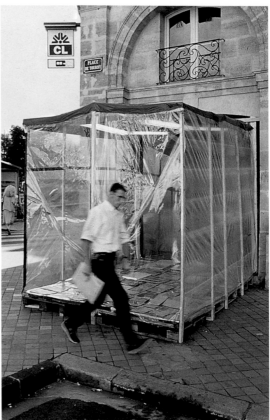
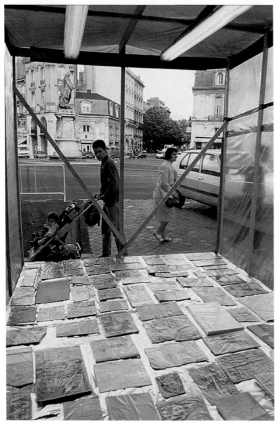
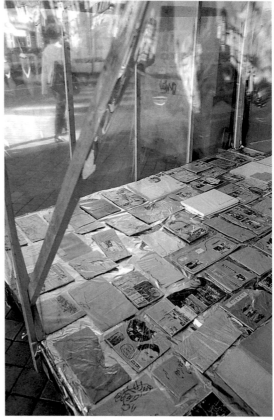

125

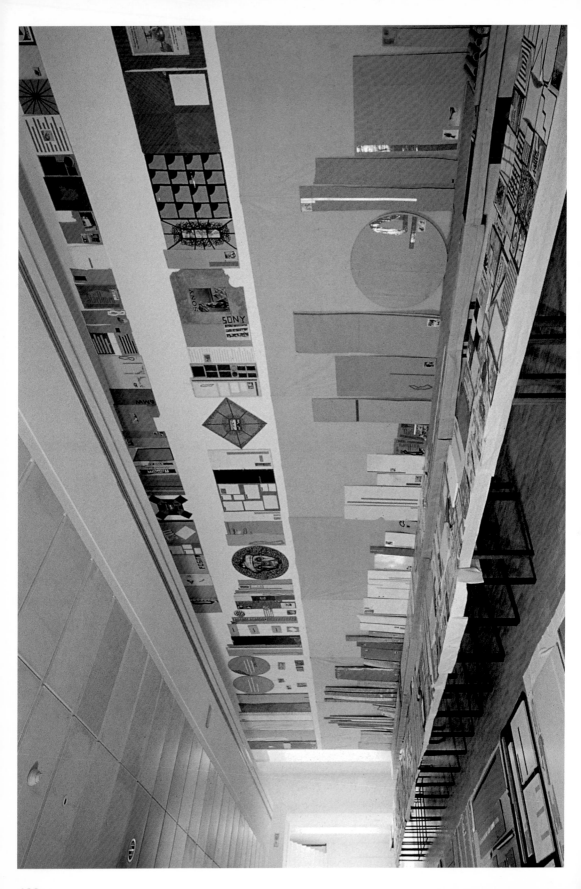

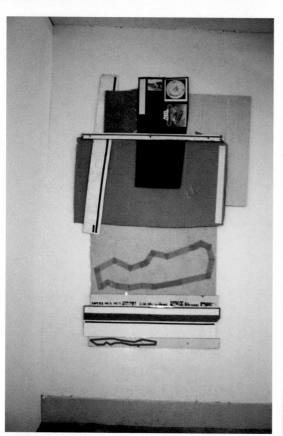

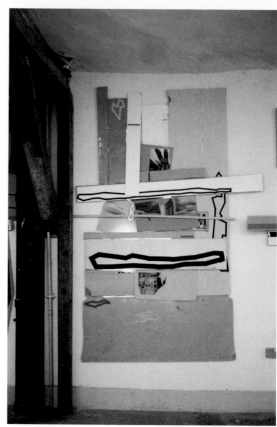

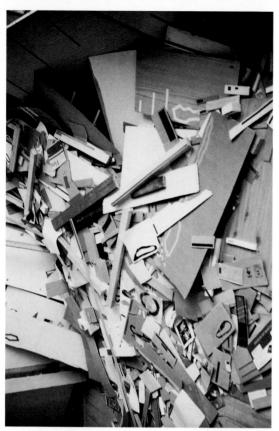

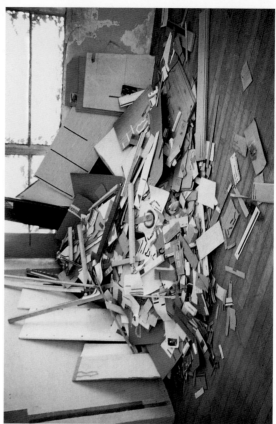

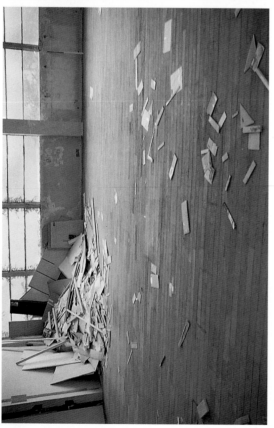

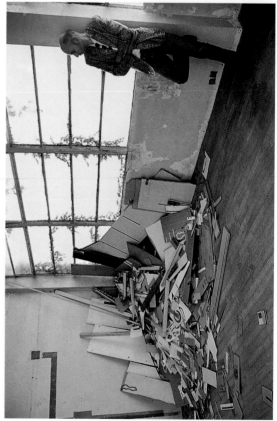

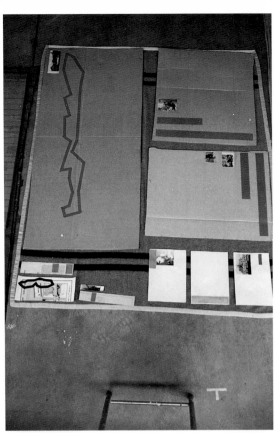

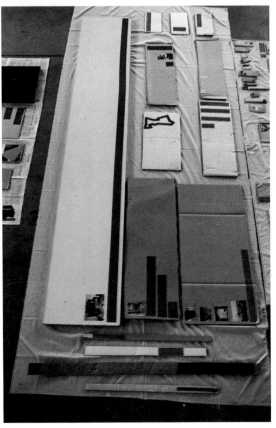

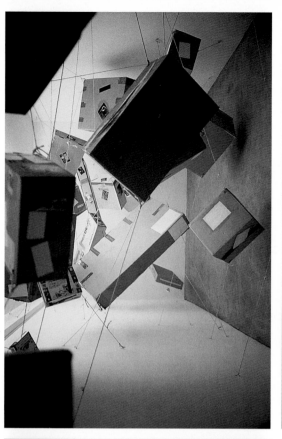
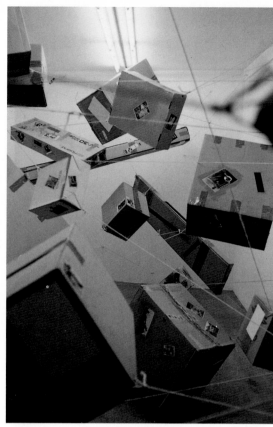
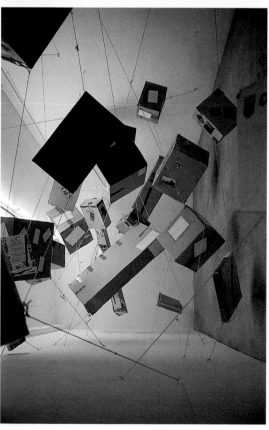
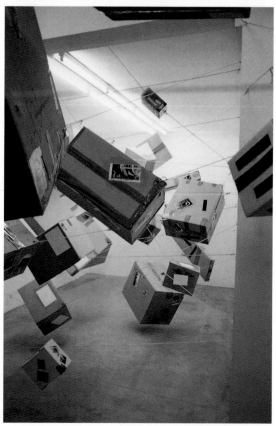

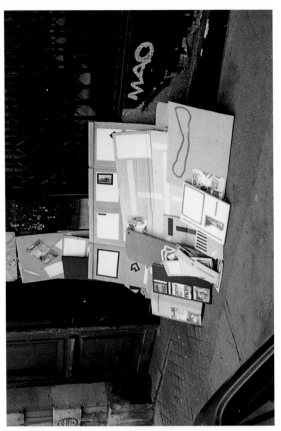

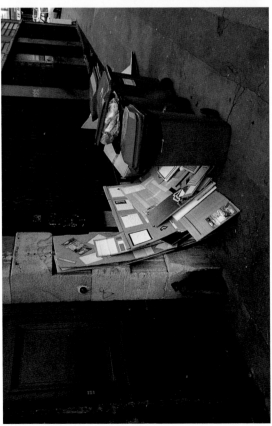

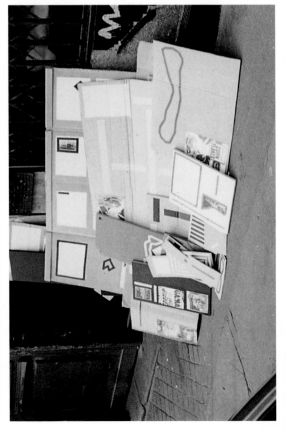

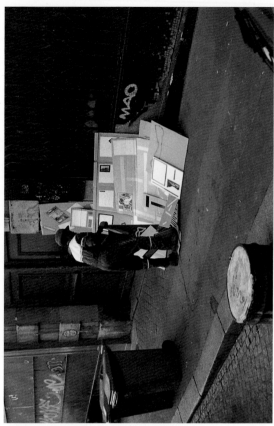
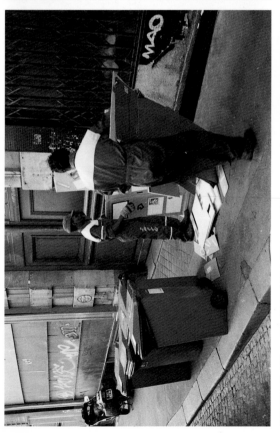
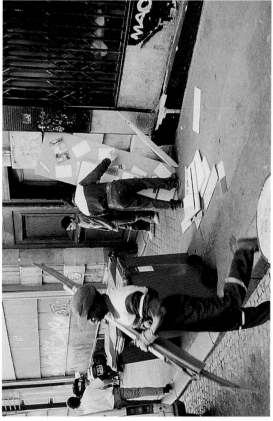

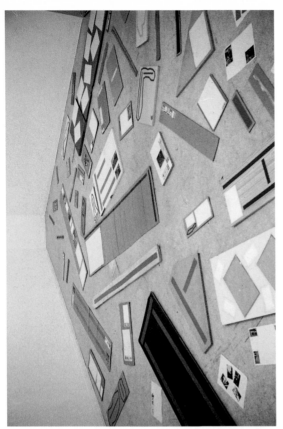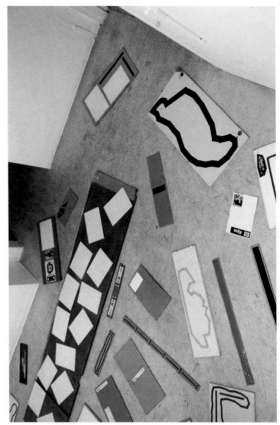

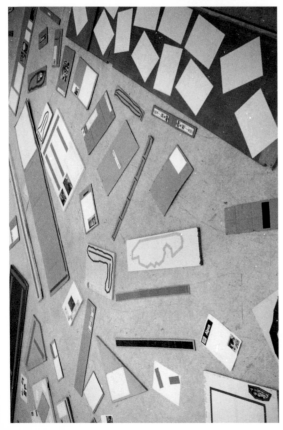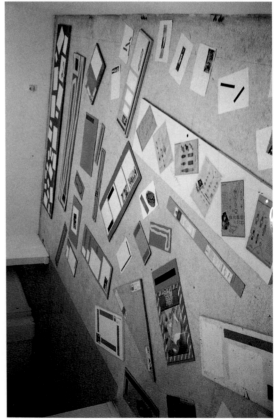

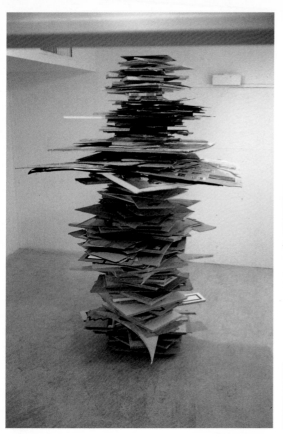

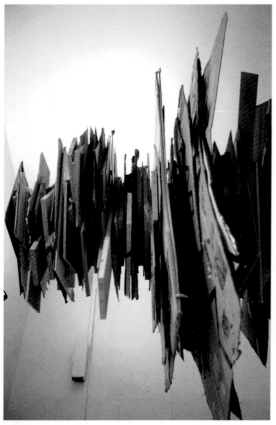

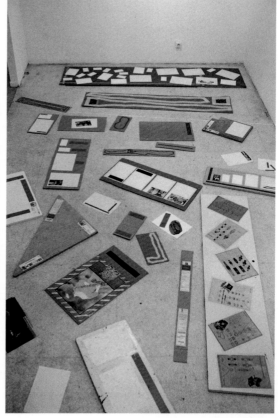

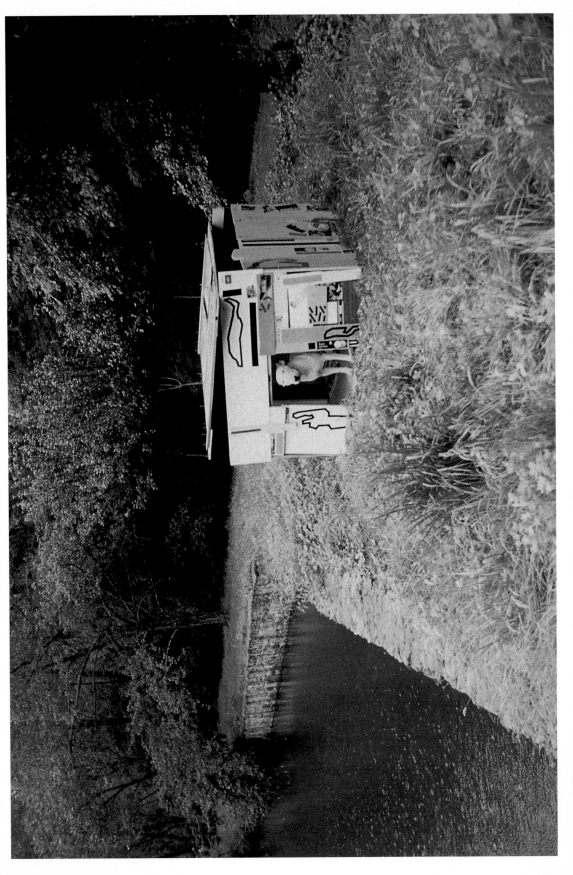

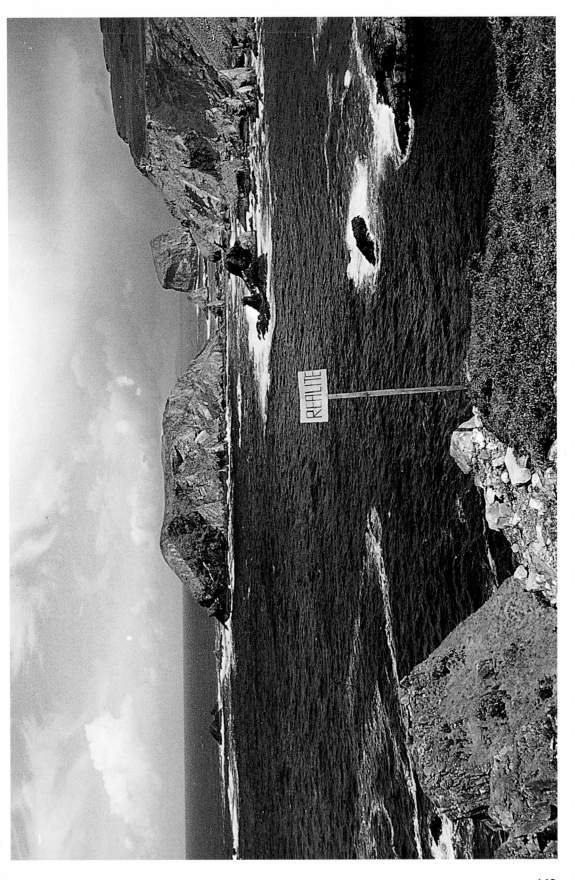